The Goddess Coloring Book

The Goddesses of the Surcadian Oracle

K. Henriott-Jauw

The Goddess Coloring Book is Copyright © 2014-2015 K. Henriott-Jauw

All rights reserved. No part of this publication may be reproduced, distributed, or transmitted in any form or by any means, including photocopying, recording, or other electronic or mechanical methods, without the prior written permission of the artist, except in the case of brief quotations embodied in critical reviews and certain other noncommercial uses permitted by copyright law.

For permission requests, please visit: www.thewormwoodqueen.com

First Printing, 2014

The Goddess Coloring book is an introduction to the Goddesses of the Surcadian Oracle and a glimpse into the world of Surcadia. These archetypes from across time and various cultures represent the energies, challenges and gifts that are within us and available to all. Each Goddess has an excerpt from the Surcadian Oracle explaining who She is in history, what her energies represent and how they impact our lives.

Exploring the Goddesses allow us to explore ourselves, grow and develop into the best of who we are. Have fun coloring, painting, decorating and meditating on the following pages!

Acheulean Goddess

The small figure found in the Golan Heights region predates European Neolithic culture by at least 2,000 years. She is somewhere between 25,000 to 80,000 years old. Also named Berekhat Ram, she was a pebble found at Berekhat Ram on the Golan Heights in the summer of 1981. An article by Goren-Inbar and S. Peltz claims that it had been modified to represent a female human figure. She is thought to be made by Homo erectus of the early Middle Paleolithic era.

Zero. The wisdom of ends leading into the dizziness of new beginnings. Here we are asked to release emotion, release our fears and take a step into the unknown because it is only after we move into it that we can begin to understand.

Wisdom is layered with knowledge and humility. It is when we accept the paradox of being nothing and being everything that we can explode our consciousness and touch sacredness.

The Acheulean Goddess knows something of this. She is a representation of the oldest Goddess named to date. She knows the cycles and circles of life. She understands that we can hurt but we cannot be harmed. Each lesson gives us opportunity and in this place exists everything and nothing. It is what we choose to create and what we choose to consume that defines our path. And as we walk it, we must understand that its boundaries are fluid and ever changing, as we need to be, in order to evolve.

Step into the unknown. She waits for you there. Perhaps to embrace you. Perhaps to kill you. The beauty lies in acceptance and the knowing that sometimes we die to be reborn and we are reborn only to die. But all the time She is with us and we are Her.

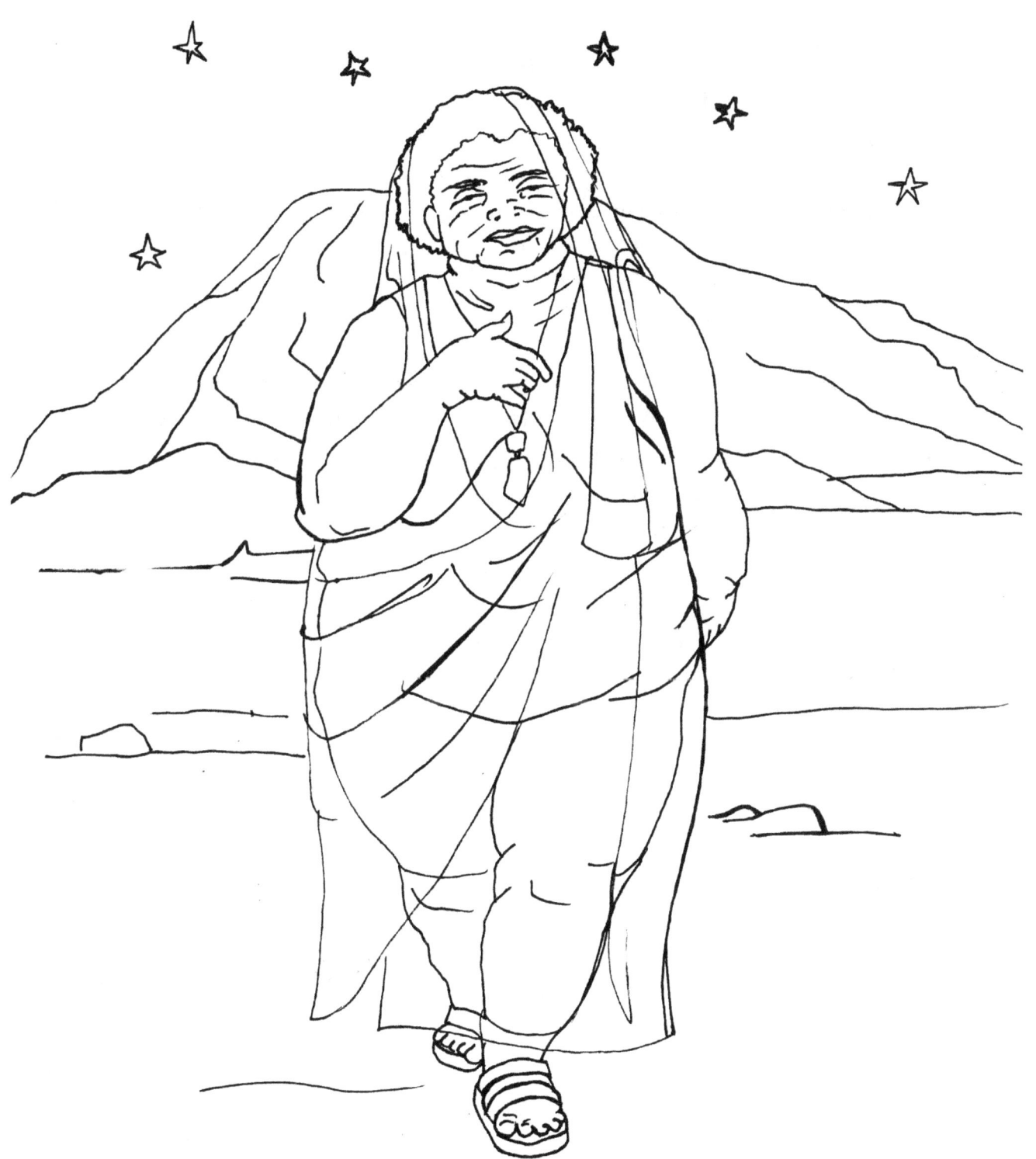

Amaterasu

Amaterasu is a Japanese Goddess of the Sun. In one of her stories she argues with her brother. Because of this She chooses to hide in a cave, a result of her anger and grief. It took Uzume, a goddess of laughter and joy to lure her out of her cave and out of her depression through Uzume's dancing and antics. When she emerged from the cave, she saw her reflection in a large mirror and was momentarily distracted by her own beauty and love allowing her to be drawn out further and never return to the darkness.

Amaterasu allows us to acknowledge our dark periods. Like those times of grief and depression. Sometimes, it is necessary to go into our caves to heal. What Uzume shows us is that we cannot stay there forever. When the healing turns to self-pity and becomes a kind of addiction we may find it takes another to be a mirror to us and show us our true selves. Show us the true beauty of who we are and not the darkness that we may have become. When Amaterasu steps in, you are being asked to bring more joy into your life. Examine your shadows and where you might be stuck. Take a look again at who you are in a brighter light. Now is the time to come out of your cave and to begin life anew. Go ahead, laugh at yourself, allow joy, close your eyes and feel the warmth of the sun.

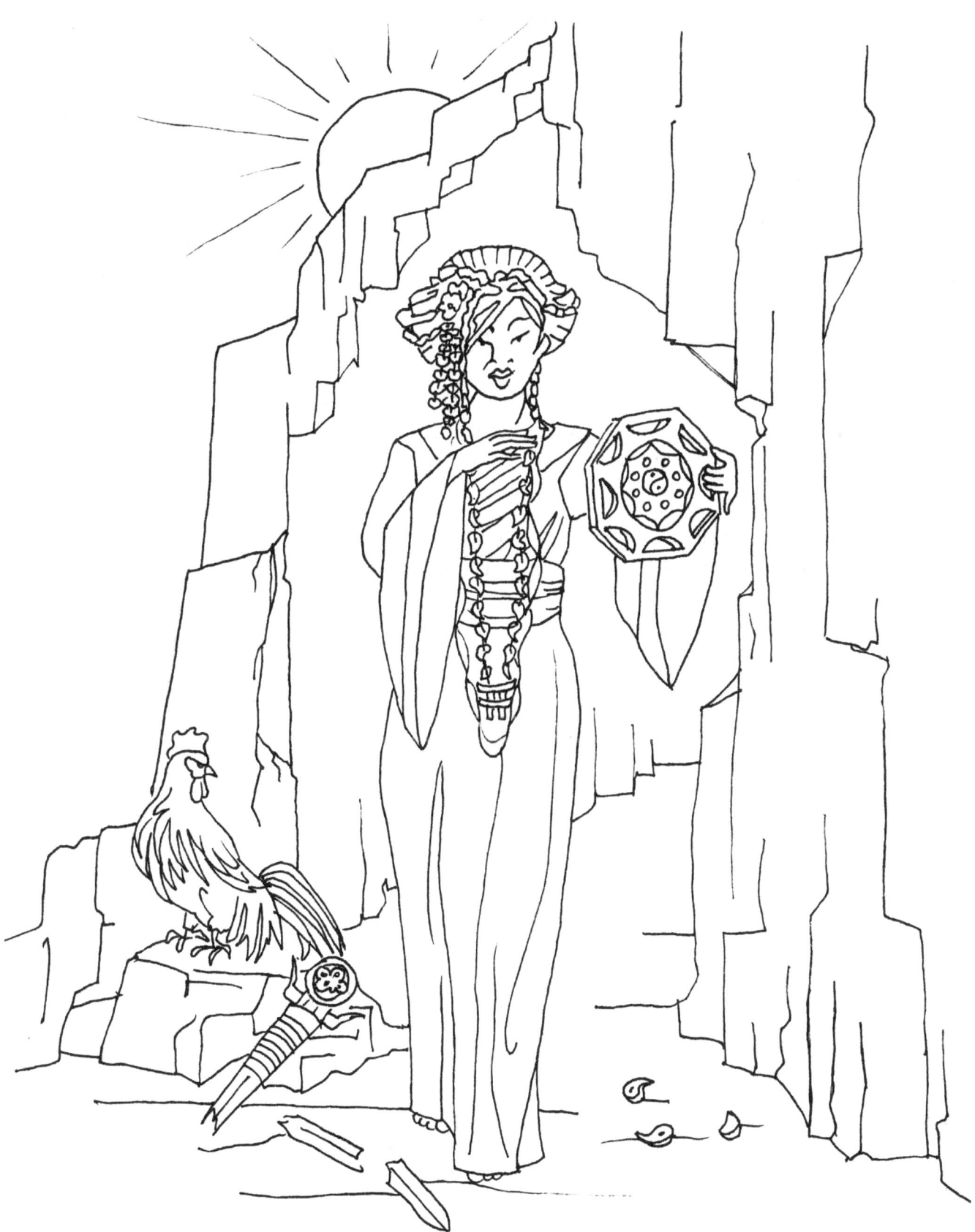

Erzuli Danto

Erzuli is a Haitian Lwo forever associated with the Haitian Revolution. In her story, she goes against rule and kills a pig in order to feed her strving people, thereby starting a war. She spits in the face of injustice. She will not stand for wrongs. She is a patron of the underdog, women and children. She is fierce, passionate and protective.

Erzuli is about finding strength in difficult times. She is about doing what you must do in order to protect yourself, your children, to survive and to fight. She is a reluctant warrior, pushed too far but once she is in the fight, she is fierce, ruthless and primal. Take a look at your fears. See why it is you fight. Remember your purpose and passion. Maybe it is time to stand up for yourself, or you may need to take a stand for another. Justice is the keyword here. Communication may be difficult at times and you may need to find another way to express yourself. When Erzuli steps in you know change is right around the corner. Maybe even a revolution.

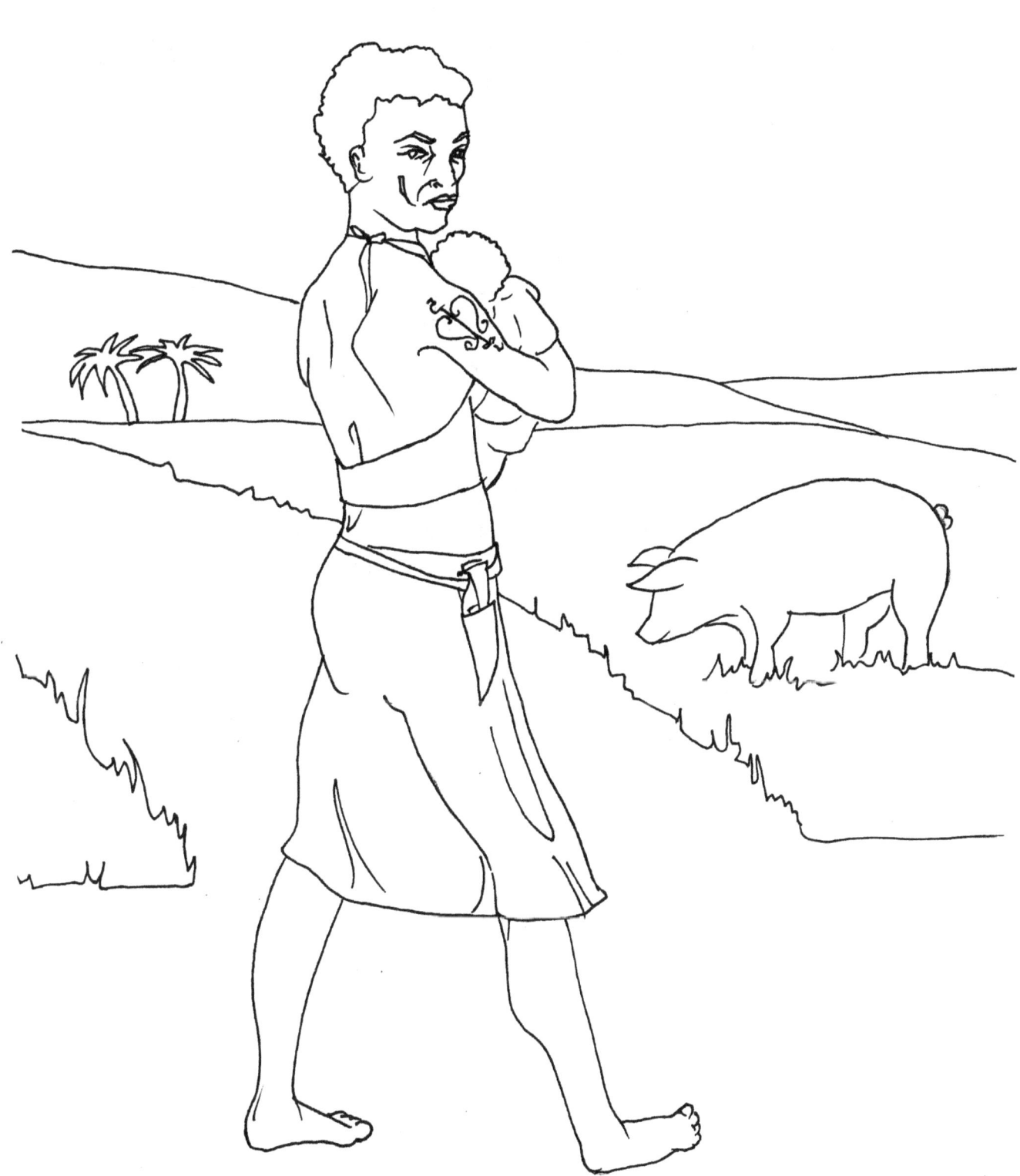

ZaraMama

Zaramama is the Inca Goddess of grain, corn in particular. Sometimes when an unusually shaped ear of corn is found it is dressed as Zaramama and is used as a symbol for good luck to the finder. Stalks of corn are sometimes hung in willow trees as a way to honor Her and celebrate.

Zaramama asks us to celebrate the uniqueness within us. She asks us to explore and celebrate the uniqueness in others. Approach life with a child-like wonder. In that, are the seeds for new growth. The seeds you plant today quickly take form and will be ready for harvest soon. Watch what you are planting. Let go of your fears and anger. If possible, get into the dirt and do some gardening, release and recharge with the help of Earth.

Be playful if you can. Look at the things in your life that you can celebrate. They may be tiny, like a seed, but they will grow. Sunshine is important, get some light into you. If it's cloudy where you are, go outside anyway. Remember that the rain is necessary for growth as well.

Zaramama can teach us patience and acceptance. She teaches us to be aware and in tune with the world and its energies. Pay attention to your physical self and its needs. Like the corn sprouting, it can sometimes be hard to push through the earth and begin your journey upward. An accepting loving attitude can help with the transition. Be kind to yourself.

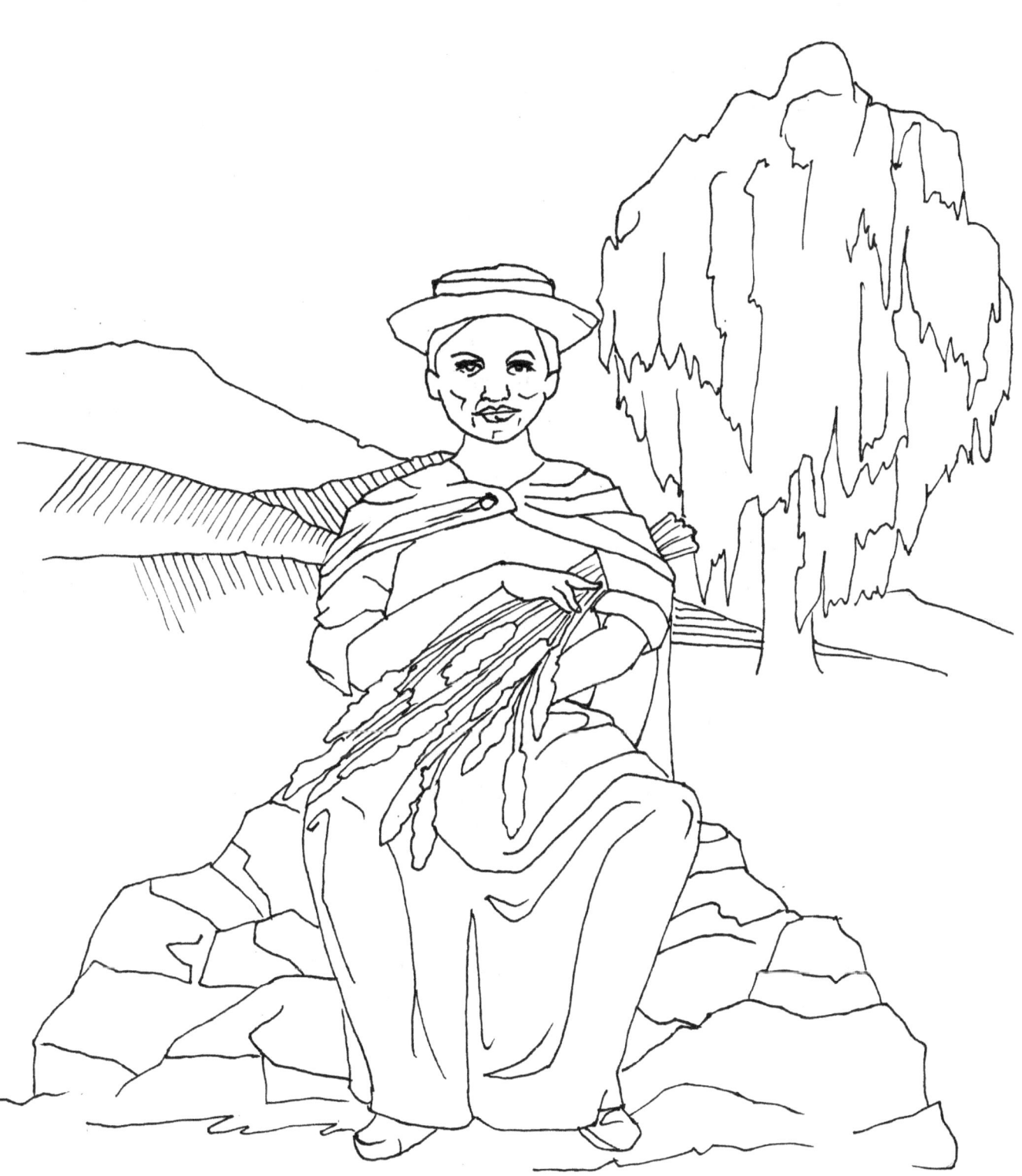

Bridget

In Celtic Mythology She was a daughter of the Tuatha De Danann. She rules over creativity, blacksmithing, home and hearth, war, poetry, healing, livestock, springtime. She was a powerful figure and force, then and now. She is fiery and strong and She asks you to be the same. Bridget, Brigid, or sometimes Brigit, is celebrated and honored during Candlemas or Imbolc in February of each year. She's the Goddess that brings light after the dark winter. When she shows up, things begin to move, birth, flow, grow, begin.

When we feel lost in the dark of winter, literally or figuratively, Bridget is the one to light the fire that warms and guides us. She is passion and creativity, headstrong and determined. She is asking us to use our passion. Find creative solutions. Remain determined. Never give up hope, never give up the fight.

There is a sexual energy related to Bridget that is in play. It's the power of creation. You are being asked to reach down into the primal source of who you are and from that, pull forth new ideas, new energy and a passion that will propel you forward to the next stage in your life.

It is understandable to feel fear, to feel nervous about all of the unknown. When the blacksmith's hammer hits, sparks fly. Bridget is hitting the hammer hard now. The heat is frightening, the noise almost painful, the sparks mesmerizing. When the metal cools we are left with a strong and powerful tool.

You have been beaten and burned, forged in the flame and Bridget has asked much of you. But you are ready to emerge, stronger than you ever were and ready for the next adventure. This time you get to be the one to shape instead of being the one shaped. You have been created so that now you can go and create. You are being given the opportunity to do big and great things. You may not see it yet but you are emerging from the darkness of winter. Whatever time of year it may be on the calendar, for you it is Spring.

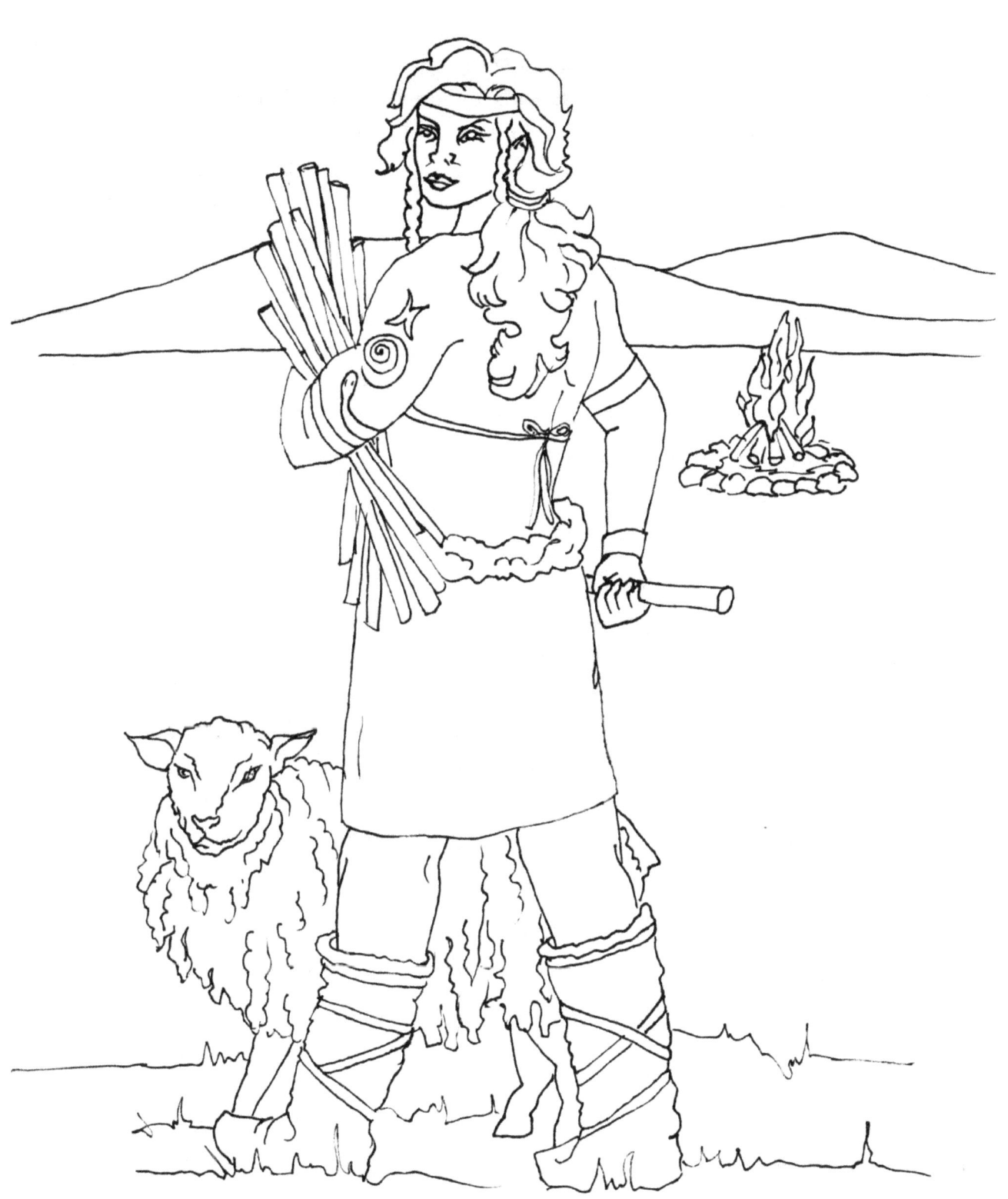

Sedna

Sedna, also known by other names in various parts of the north, is an Inuit Goddess of the sea. But before she became a part of the sea, she was a young Inuit maiden. Her story, like her name, varies but there are a few consistencies among them all. Briefly, those things are that she takes to her father's kayak, he pushes her over board to avoid the wrath of the Raven, She hangs on and he chops off her fingers, forcing her to let go. She sinks to the bottom of the sea and is worshipped by those who depend on her goodwill to supply food by releasing the animals of the ocean.

Sedna could have become a victim. She could have blamed everyone else for her troubles. She could have sunk to the bottom of the ocean and died. But she didn't. She began as a maiden and was transformed into a Goddess. She understood that blame becomes irrelevant, it doesn't change the situation, it's what you do with it that matters.

Sometimes the sound of a door closing can sound more like the chop of an axe and instead of a slam. As you cling to old paradigms, as you cling to what is known, as you cling to the side of a kayak that is no longer seaworthy, chop, chop, chop as your fingers fall away and you lose your grip. All you have left to do is to surrender. To fall back into the arms of the sea and pray you don't drown. And it's in the surrendering that we can see solutions, we can see life, a way up and a way out. We have to use ourselves, our creativity, everything we've got and everything we are. And sometimes the only thing we have left is the magical thing. When we've exhausted every other option and we realize that so called reality is no longer our reality, or maybe it never was. And just maybe, that's not a bad thing at all.

It's time to allow the solutions to come, to allow the transformation, to create life from seemingly certain death. Seemingly certain, because with Sedna, nothing is certain and death is an illusion. It's not the end it's a redirection.

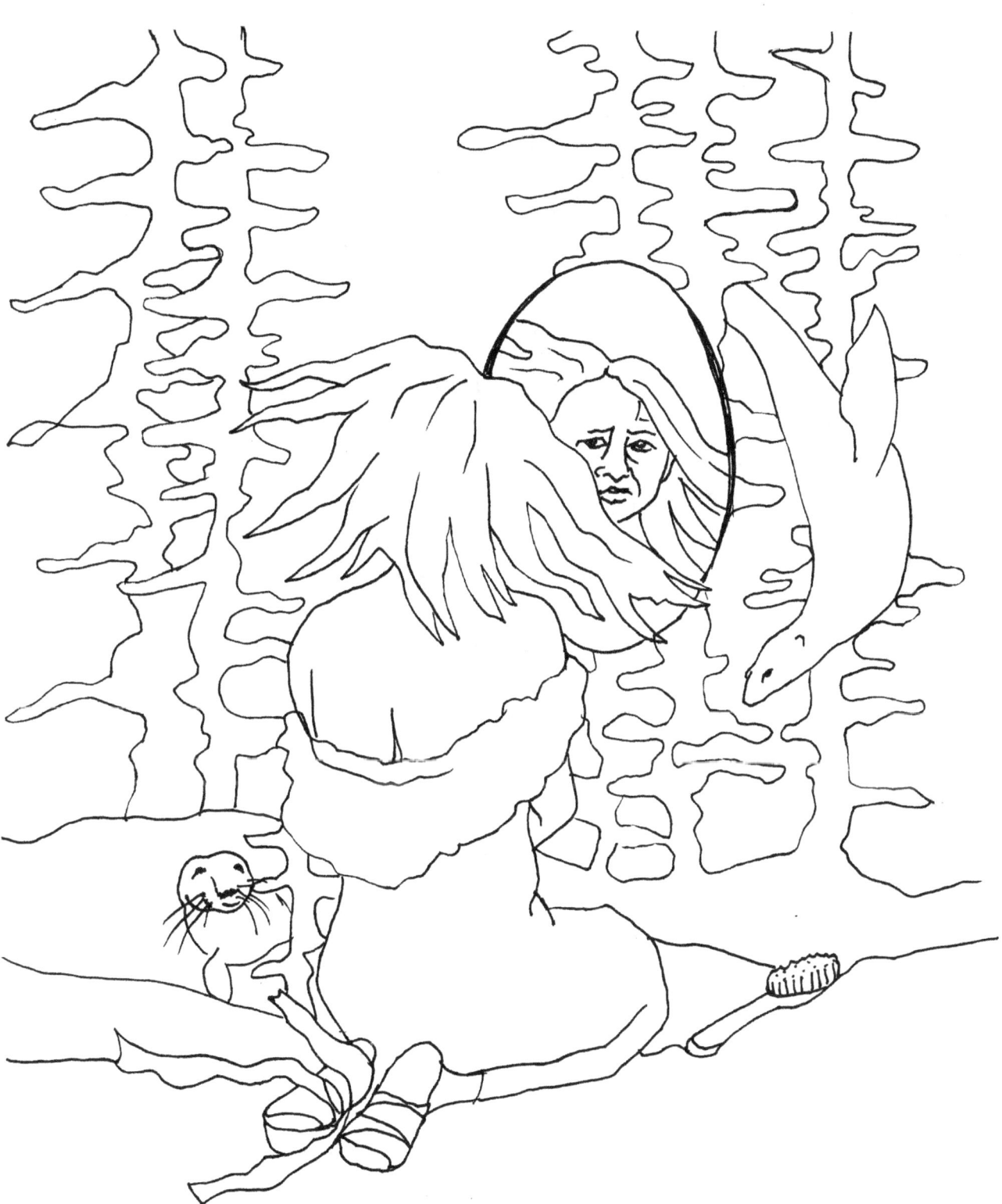

Xochi Quetzal

Xochi Quetzal is an Aztec goddess. She is a goddess of passion, excess, sex, beauty, fertility and earthly pleasures. She is known to protect mothers, especially during pregnancy and childbirth. She's also a creative goddess inspiring art and crafts of the day such as weaving.

In our society, we are often told that our bodies are bad. We are told that to evolve and become enlightened we must escape our earthly desires and our physical selves and become more spirit-like. We forget that the tools we have to do this reside in our physical selves. Xochi Quetzal asks you not to separate the two but combine them. Go into yourself, feel your body. Check in with each cell, each breath, each smell, each urge. Feel them. Honor them. Experience them. Use all your senses to explore your bloody, snotty, smelly self! Begin to accept these parts of yourself that have amazing purpose and creative potential. This is not the time to hide. There is no time for shame. Know you are beautiful, in your body. Know you are wise, in your body. Know you are powerful, in your body. There are many things we can "know", in our heads. Learning to "know" them in your body is a whole other level of wisdom.

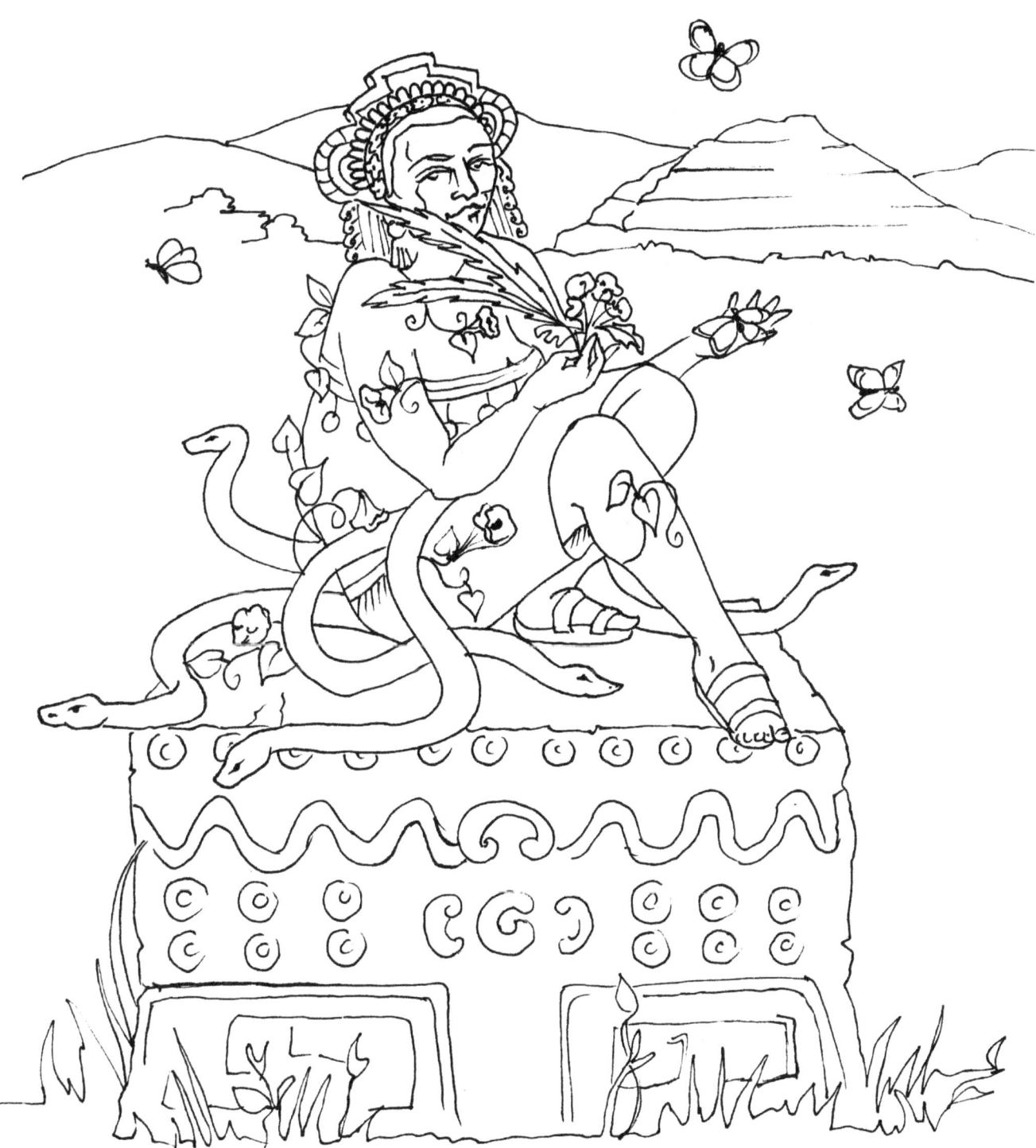

Isis

Isis is an Egyptian goddess of marriage, magic and love. Modern and historical depictions of her show Isis as a queen, poised and elegant. But years ago she visited me in a dream and she was real. She was down and dirty. She was unadorned, sweaty and was assembling body parts. She looked at me in a way that told me I had better watch and I had better learn, that I needed to do this too. Isis can show us how to put all the pieces together, reassembling them, animating them, breathing into them new life.

It's time to collect your stories, thoughts, observations and experiences. Sort through them to make connections and to find direction. Decide if you should breathe new life into them...or not.

As you mentally simplify your scattered thoughts, their "forms" disappear and you can began to recognize them as simply energy. Energy in and energy out. Masculine/Feminine, Yin/Yang, Good/Bad, are all judgments. Realize that, when simplified, it is all just energy and different levels of acceptance and rejection of that energy that can lead to imbalance.

You may notice a sort of energetic hoarding due to fears and judgments. Sometimes that can collect in your body, like stress/tension in your shoulders. Let it go. It takes conscious effort to become less concerned with the labeling and judgment and more concerned with the movement of energy.

Breathe in and breathe out. Move and flow. It's sad that such a natural thing does not come naturally to many. I think it must have at one time, far too long ago now for most to remember. Chose to remember this now: "I don't exhale with the fear that I won't be able to inhale again. There is plenty of air. It's all around me. "

Isis tells us to use our magic.

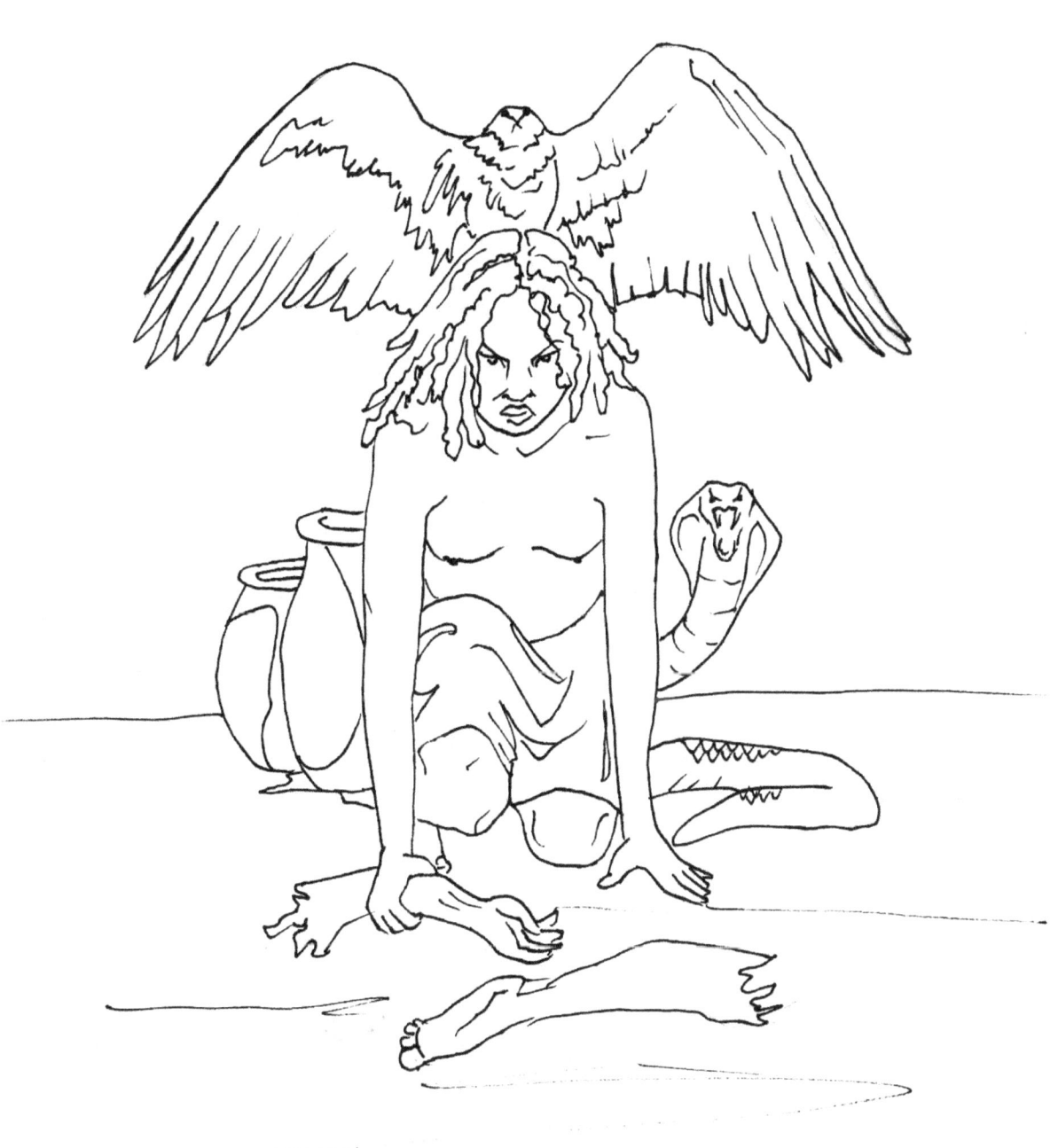

Kali

Kali is a Hindu Goddess of destruction. She's a pretty fearsome character. As I think about Kali. I think about my fears. When my husband and I were talking about this project I felt fear. Fear of not being able to paint what I want to. Fear of being told what to do. Fear of endless discussions and never getting to the doing. All fears that I needn't have had. Fears that dissipated once they were expressed and we had a real conversation.

Most fears stem from the idea of not being in control. Finding faith and surrendering to something bigger can be freeing and scary. Mentally we can know that there is strength in vulnerability; that there is power in weakness. It's a paradox. And it's a truth. But it is one thing to know this logically and quite different to know it experientially. And Kali is all about experience.

To understand Kali, one needs to face fears and not avoid the forbidden.

Kali's hair is always a mess, wild and free. (I know how she feels) It's never depicted as bound or styled because she is free from convention. She is uncontrolled nature. She is not bound or limited to a partner. Her tongue is in the act of tasting and consuming, enjoying all the world's flavors. Her blackness symbolizes her comprehensive nature, in her is dissolved illusion, fear, ignorance. The severed arms she wears as a skirt represent karma. She shows that through her, Karma can be overcome. She can cut you free from your karmic past and allow you to begin anew. Two of her hands are shown in the Mudras, She offers blessings of compassion and fearlessness. The other hands hold a sword and severed head. These symbolize the destruction of ignorance and the beginning of knowledge. The necklace of severed heads represent the sounds of the alphabet, traditionally there are 50 of them, I took liberties. From sound, reality is manifest...and Kali is the power behind that.

Control is an illusion created to mask your fears. Kali forces you to surrender to your primal urges and desires and face your fears. Go ahead, scream, dance, cry feel the freedom of your human-ness and in it you will feel the power of the Goddess.

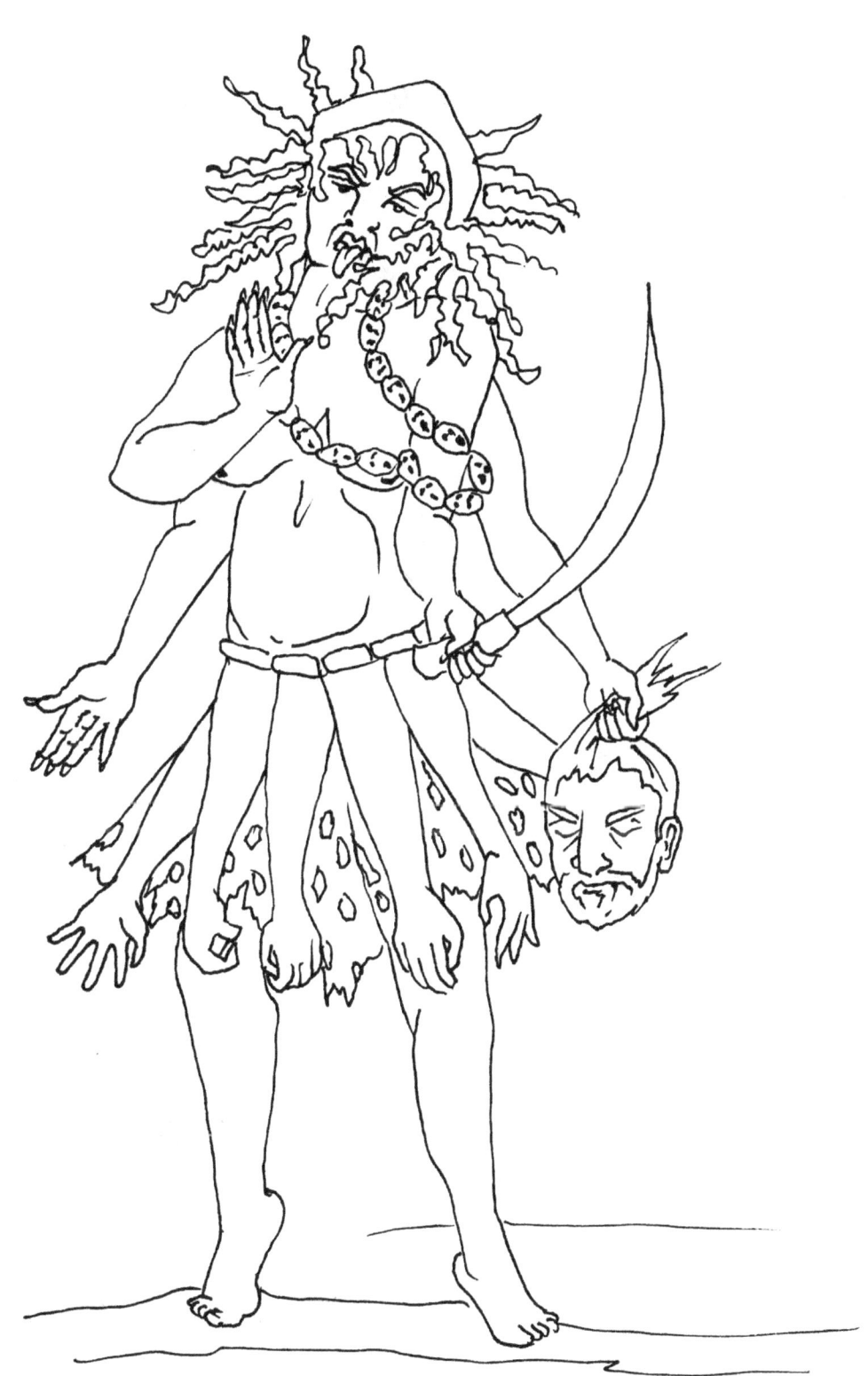

Pele

When the volcanic flows start in Hawaii, people leave notes, messages, offerings and prayers to Pele. They put them in front of the flows waiting for them to be eaten by the Goddess, just as She will eat their homes, their schools and their villages, if they are in her path. When the lava flows, people pack their belongings and move. They understand what it literally means to have to "go with the flow". When Pele speaks, people listen.

Pele is a proud, temperamental, fierce Goddess. She is fearless. Here is She is shown sledding down the mountain on a papa holua. When She shows up she will undoubtedly change the landscape of your life. She asks you to look at what needs to move and change in you, your job, your relationships. She asks you to 'go with the flow" and allow what is necessary to happen. After land is scorched, new growth occurs. The soil left behind is more fertile than before. Trust Her wisdom. And get ready for the ride of your life.

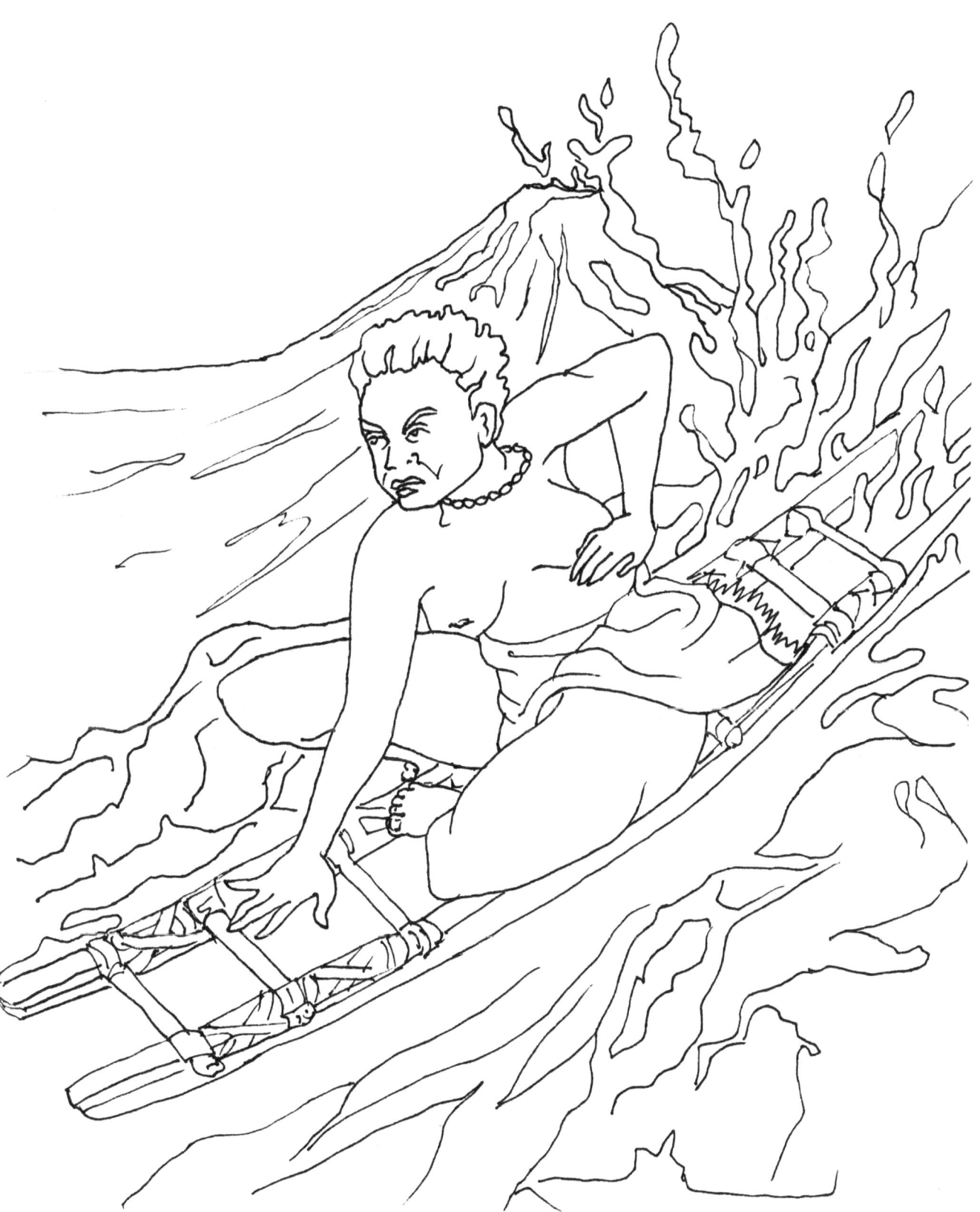

Mari

Mari is a Basque Goddess. She is one of the few Basque deities that survived Christianity. She is associated with storms, wind, hail and nature. It said she lives underground in a cave and when she rides through the sky you'll know! Mari is wild and free. She is a powerful natural force that moves through us all.

She is ancient and she won't hesitate to call you out, force you to see your illusions and change your unhealthy strategies. Like the wind she will blow through, creating storms where necessary. When those storms come up, look for the opportunities. Understand that when the wind blows down those branches, it is because they were old, damaged or dead. They needed to be cleared in order to allow for new, healthier growth.

Hers is a "big picture" wisdom. She does not care for small minds or personal drama. She asks you to redefine yourself and see how you fit into that big picture. There is no time to waste. Learn how to ride those storms and bend with the wind. Learn what it is you need to do and apply yourself to that bigger destiny. Perhaps YOU are Mari and you need to learn to use your voice to teach others these things. Show them where they are in illusion, initiate them to a higher level of being. But do not get caught up in the drama. Be a force of nature; no judgment, only action.

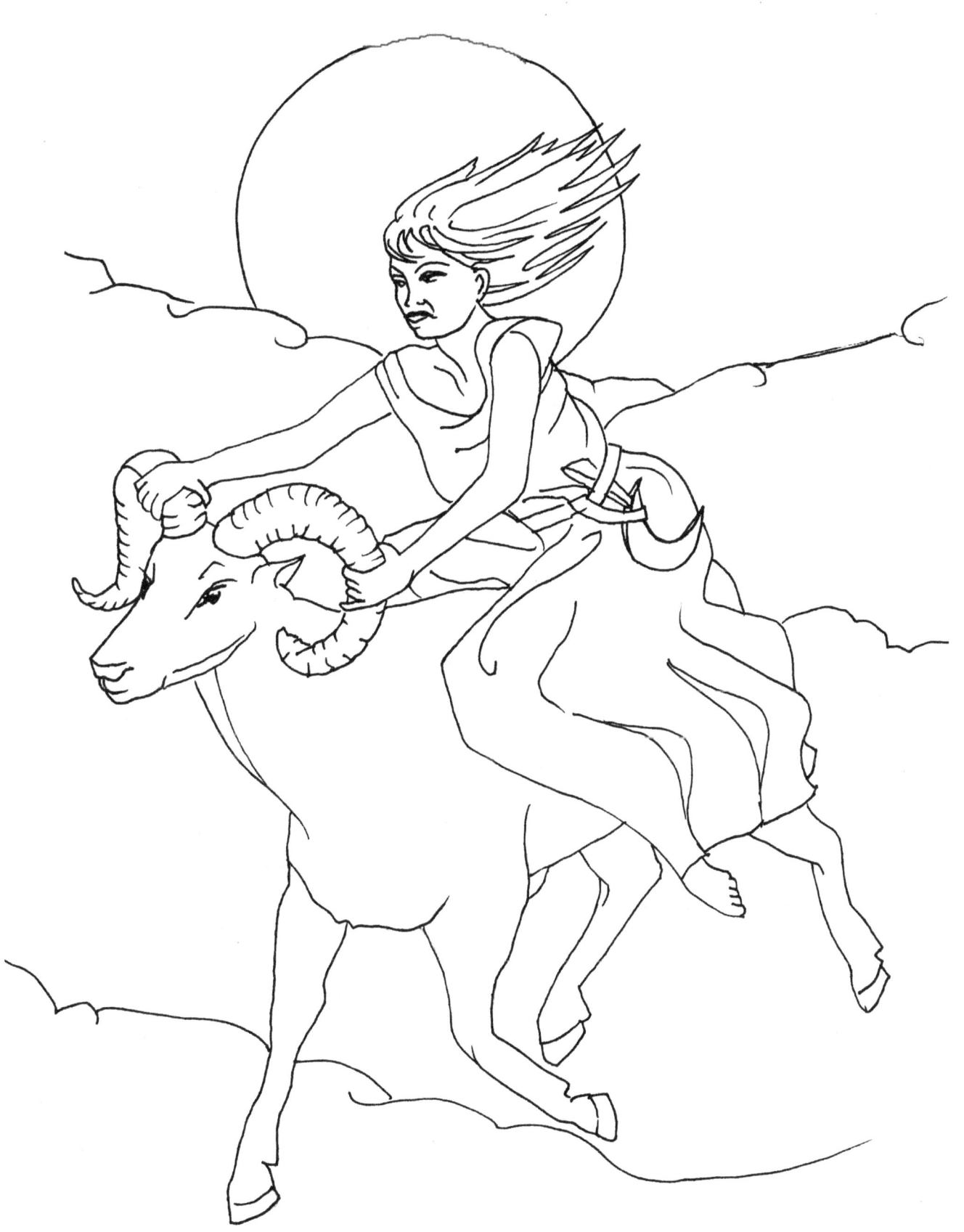

Rangda

Rangda is a Balinese Demon Queen. She is blamed for blight, illness and death. Each year there are ceremonies performed that show her being defeated by Baraong Ket, the leader of the forces of good. She is depicted as a cannibalistic demon who feeds on babies. But is she? Some say her story is based on that of an 11th century Balinese queen named Mahendradatta. Mahendradatta was said to have been banished from the kingdom when she was found to be practicing witchcraft against her husband's second wife. It is also said that she was banished because she was older, no longer desirable and divorce was not an option. Taking to the jungle she survived another day to seek her revenge. Though feared by many, she is also considered to be a protector of women and children. Especially those who are in abuse situations, or those who have been wronged. She is strongly associated with Kali.

Rangda can represent the eternal struggle between good and evil and the internal struggle between the desire to express ourselves and society's desire that we repress ourselves. Resentment, bitterness and anger held in for too long can result in chaotic outbursts or even Kali- like rampages. Rangda is the unrestrained, passionate, sexual, desirous us. The one that bristles at bullshit and refuses repression. She recognizes that we can choose to fall into victimhood or we can choose to fight back. She is a woman of action, fearless and strong. She teaches us that if we hold back for too long, we create imbalances, ill health and misplaced angry outbursts. When she shows up we know that the pendulum is swinging the other way and it is time we take a good long look at our lives and our situations and we learn to live true to ourselves, stand up for ourselves and find the power in our BEING.

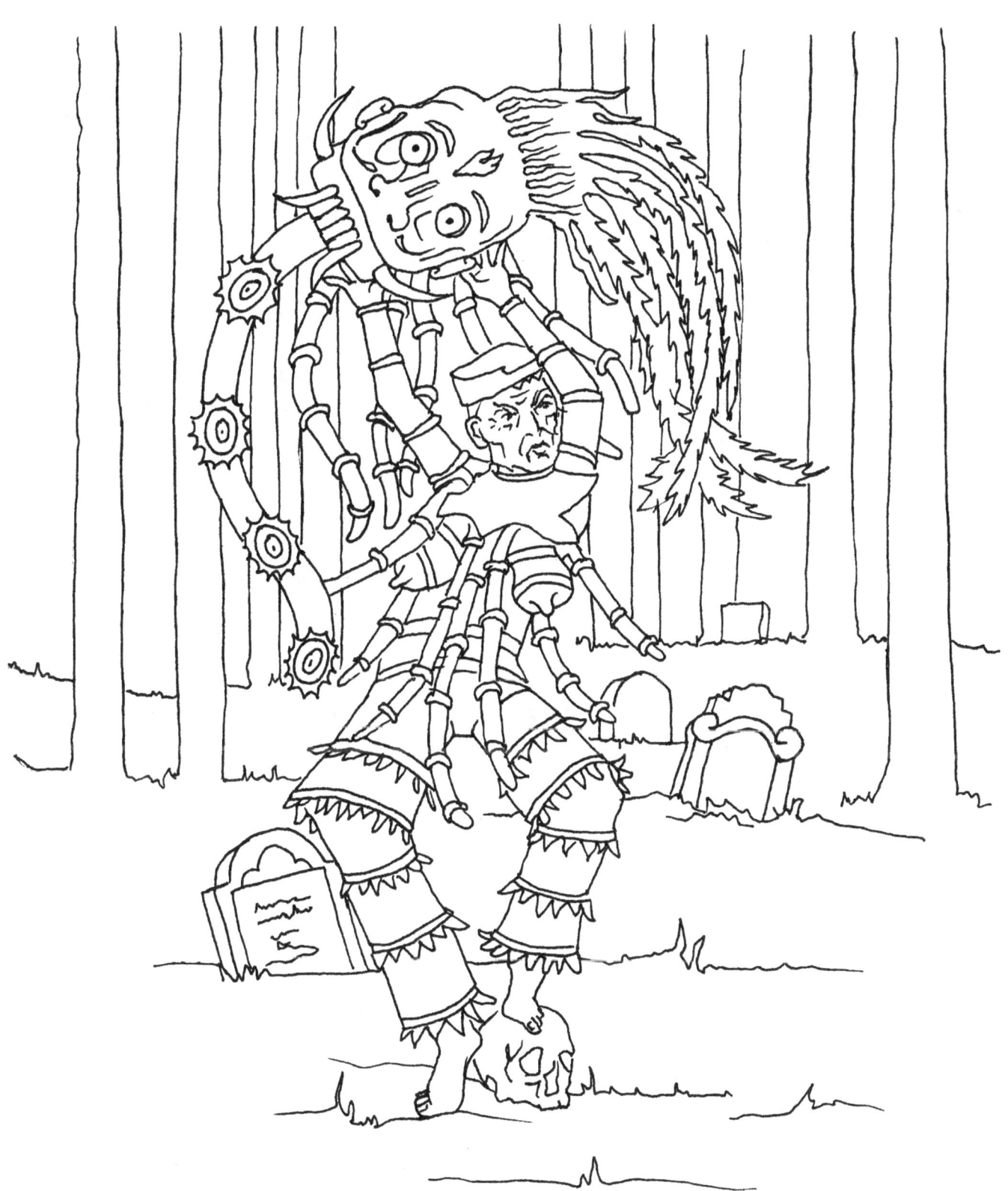

Ala

Ala is an Igbo Goddess from Nigeria. She represents morality, creativity, death and life. She is a fertility Goddess and She rules over the underworld. Just as a mother holds her baby in her womb and brings her to life, her spirit will return to Ala's womb after death. She is the great mother. She is the earth, She is the ground, She is the underground. She is darkness and she is hope. She is about endings and beginnings. She is the one that holds us to a higher standard. She keeps us honest.

Special structures called Mbari are built to honor Ala. They are mud houses, elaborately built and consecrated to the worship of Ala. Where they are built is decided by a sign from nature, from the earth, from the Goddess herself. Where a bee or snake shows itself is where the Mbari is built. Perhaps a bee or a snake has shown itself in your life or in your dreams. Notice where they landed, where was it that they crawled?. Were you stung or bitten? It is here that Ala wants you to focus your attention. Are you being honest with yourself in this situation? Is your character good and strong in your dealings with others? Is this a cycle or a pattern? If so, determine whether or not it is something to be birthed or something to let die.

Ala guides our ancestors and our ancestors guide us. Listen to their wisdom. Watch for the signs. There is no time for falsehoods only the (sometimes brutal) honesty of life; and death.

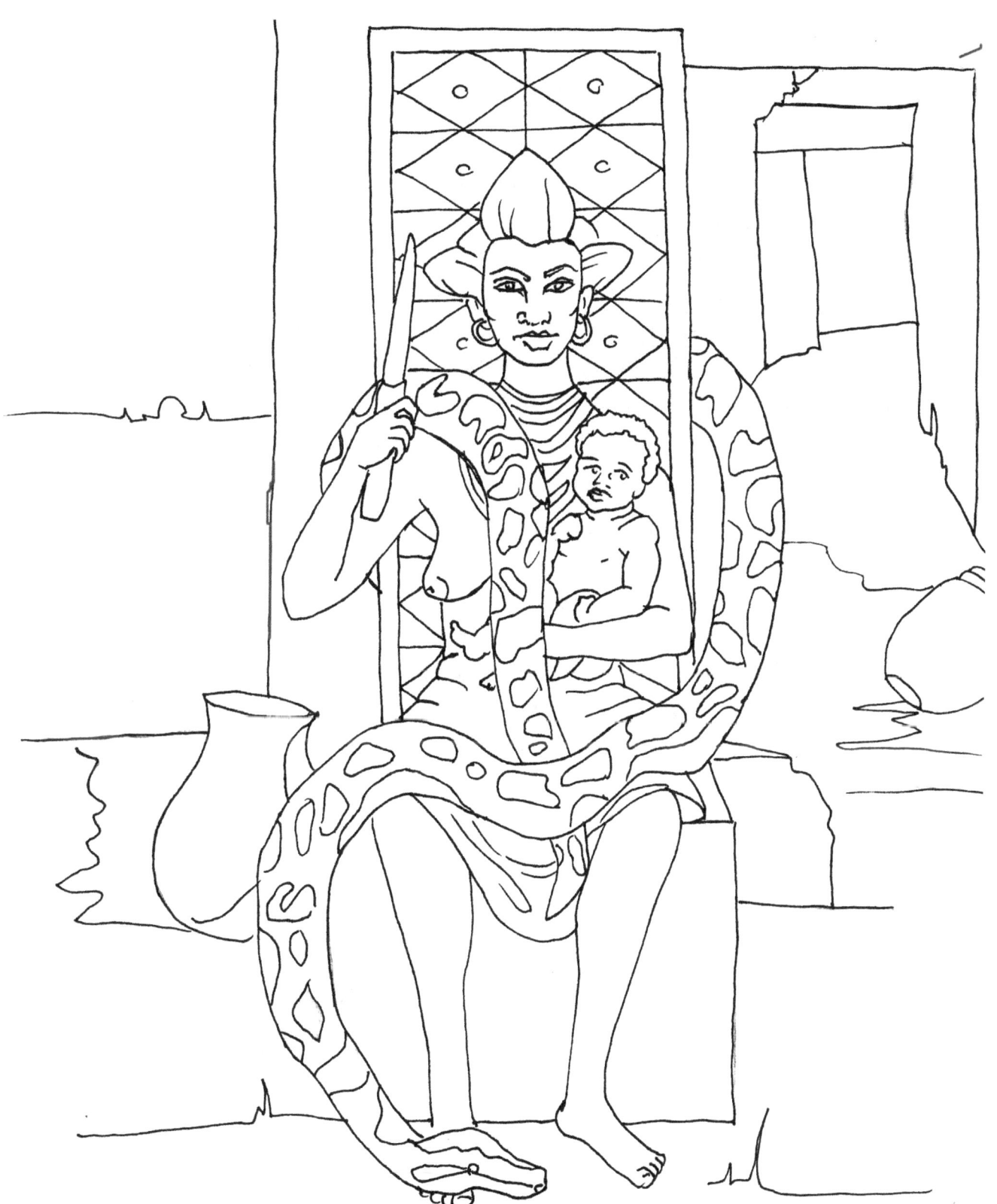

Santa Muerte

Nuestra Senora de la Santa Muerte or Our Lady of the Holy Death is venerated primarily in Mexico and in the Southwest United States. Her history goes back to the indigenous culture of Mesoamerica. She has survived until now under the guise of the synchronized folk saint, not recognized by the Catholic Church, but still honored by the people. Especially those in the lower working class and the outcasts of society understand and revere her. For them, death and hardships are an everyday fact of life. She is the one that recognizes this, does not run from it. She is real and honest. She is petitioned not necessarily for survival, but also for safe and quick passage when the inevitable happens.

Santa Muerte asks us to not fear endings. Instead embrace them just as we would life. She understands that life is not linear, there really are no endings or beginnings as the circle turns. She will help us on our journey around the wheel. With her by our side we can face down our fears and find strength to continue on. Holding onto decay, trying to resurrect that which has clearly moved on causes pain and suffering. Sometimes we can fear the new life just as we can fear the death. Change of any kind can be unnerving. But change is constant and will always lead to growth and wisdom if we allow it. Santa Muerte teaches us to let go and accept when it is a good time to die.

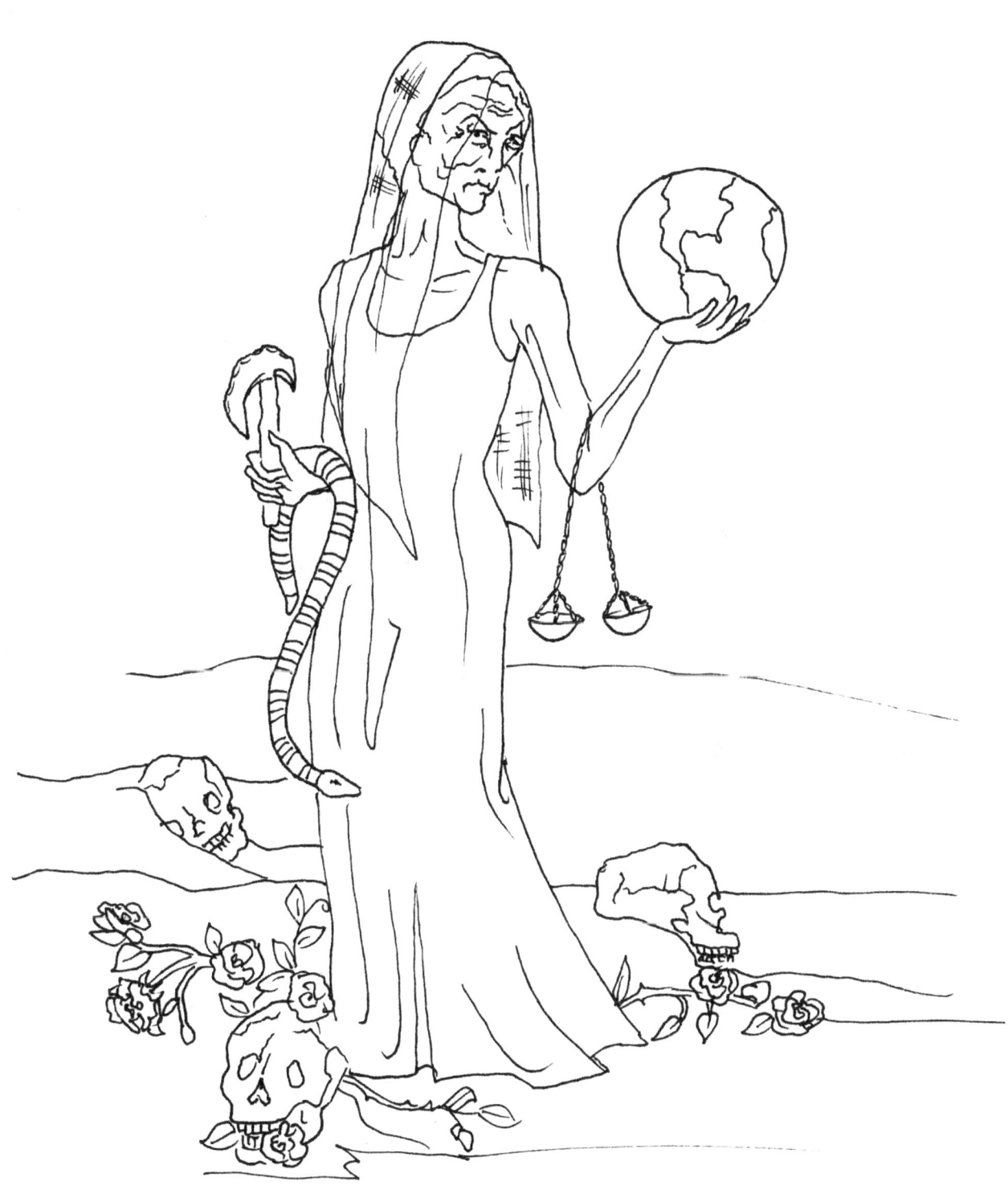

Baba Yaga

Baba Yaga is a Slavic Witch/Goddess. She turns up in many fairytales, always a rather scary character. She is a Goddess that strips away all the crap and gets right down to the bones of a situation. She reminds us of the need for a strong foundation. A foundation that is solid, not littered with fears and illusions.

Hers is not a fun energy to live in. Baba Yaga teaches us that we cannot pretend. We cannot pretend that everything is okay when it is not. We cannot pretend that we are someone we are not. It is easy to get caught up in distractions and illusion. They are what keep us from facing often painful realities. Baba Yaga will strip that all away. She teaches us that the only way to happiness and peace is through honesty. She will be painfully honest in assessing your situation, she will not mince words. She doesn't care. She has no time for sugarcoating, she will not enable. She demands that you step up and be accountable, be responsible for your choices and your decisions or she will not allow you to go further. You will never leave her bone yard alive.

The choice is enlightenment or death. She will trick you, twist you and test you. It's only painful if you fight. Surrender to the honesty, let the illusions fall away. Rip off the proverbial band-aid, it will make it a whole lot easier.

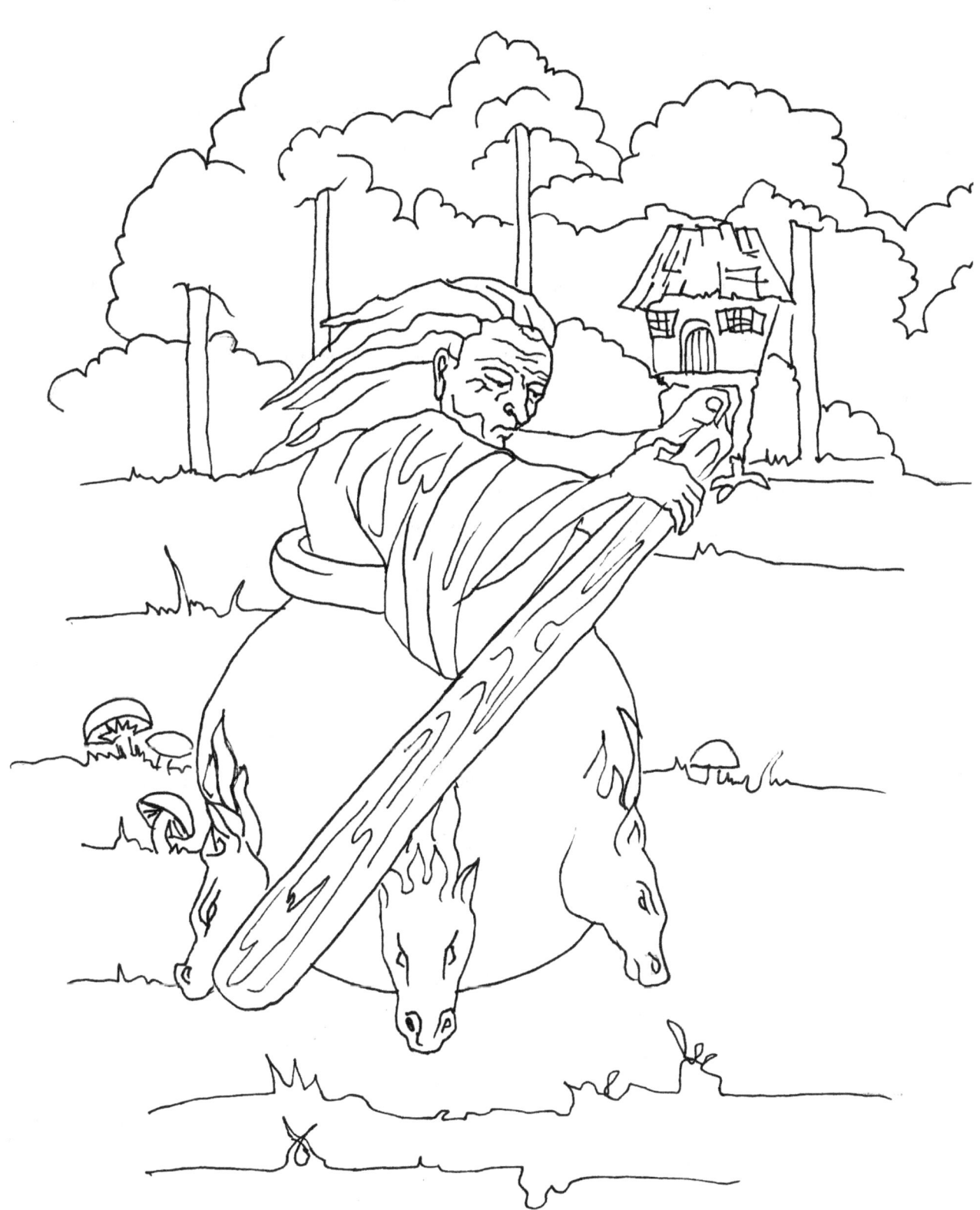

Kamuy Fuchi

Kamuy Fuchi is the Ainu Kamuy, or Goddess of the Hearth. She is the gatekeeper of communication between the living and the dead. She represents family, ancestors and your soul pod. She is a teacher of the people and oversees all domestic affairs and relationships.

It is said that Kamuy Fuchi never leaves the hearth. And why should she? The hearth is the center of the home. Here is the flame that warms our bodies, cooks our food and sustains our lives. Here is the place where souls return and wait to be reincarnated once more. Here is the place where families come together.

How do you maintain your "hearth"? Is it clean with a fire burning bright? Or is it covered in soot and your flame dwindling? It is time to clean house. Often doing this literally, helps us to do this on an emotional and mental level as well. See how what you have around you and what you are bringing into your space is affecting yourself and your family. It could be that there is someone around you who is being disrespectful to this sacred space.

Community space, family space should be respected by all. Are you enabling by cleaning up after everyone's messes? Are you or others being disrespectful by bringing in clutter and leaving it for others to work around? Think about this not only in a literal sense but in a metaphorical sense as well. Sometimes the words we use as well as our actions can be just as messy as those dirty dishes left all over the kitchen counter.

Call on Kamuy Fuchi to help in your marriage or in family disputes. Like a tough grandmother she can deliver the swats as readily as the hugs. Though you cannot change others, she will guide you to making changes in yourself; to become more self- aware, allow for self- respect. She teaches us how to nurture that spark and that flame within ourselves. She allows us to talk with our ancestors, living and dead and to make connections that further us in our destiny. She reminds us that sometimes our family is not only those that share our DNA but those with whom we have incarnated time and again. Kamuy Fuchi shows us how to clean up our acts and stoke the fires of a warm and sustainable life.

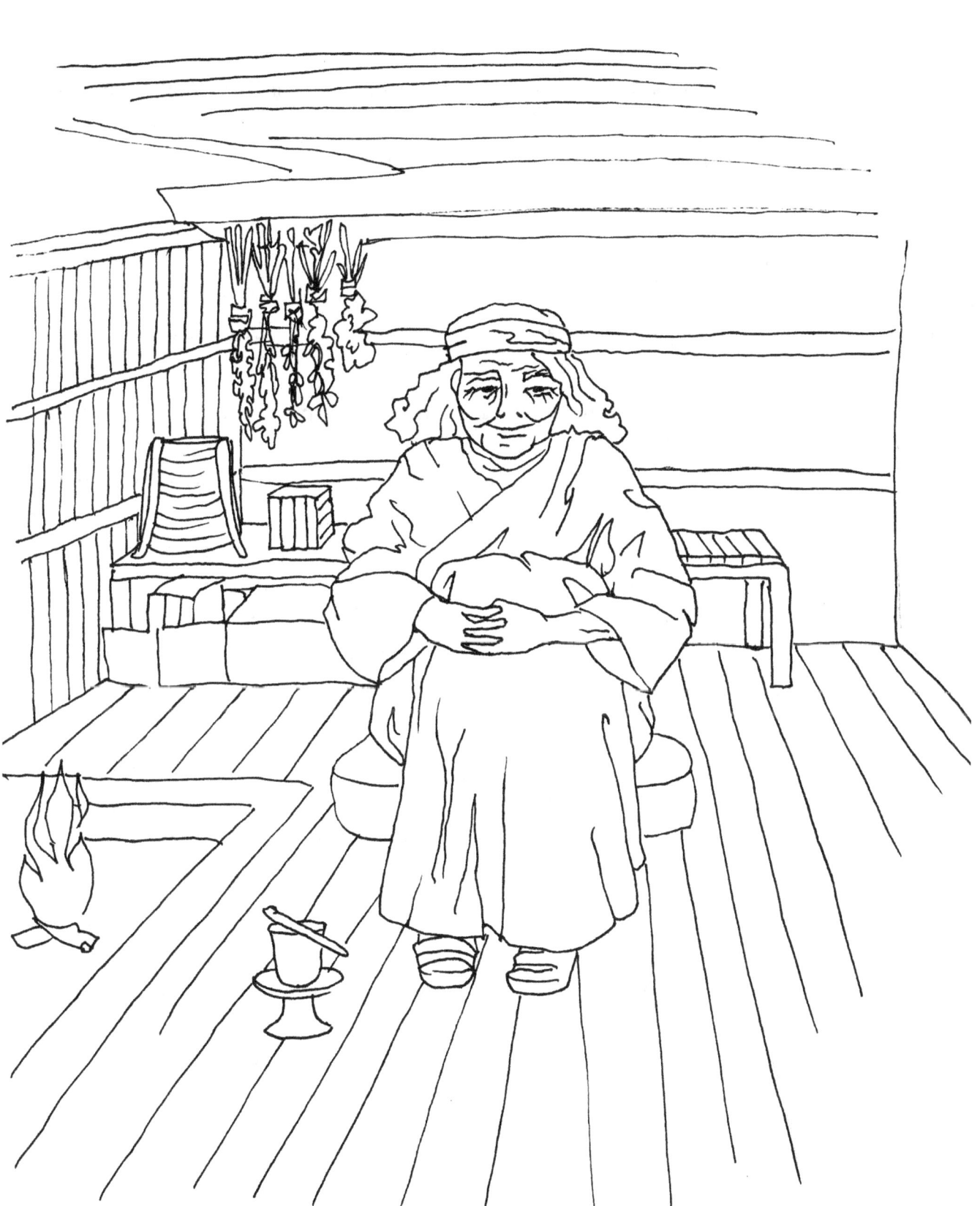

Kuan Yin

Kwan Yin has a couple of stories and many different spellings of her name. She is a bodhisattva "who hears the cries of the world." She is thought to have originated in China around 400AD. Originally, she was portrayed as male. There are several stories about Kuan Yin. In one, she decides to become a nun as opposed to agreeing to an arranged marriage. Her father, after failing to dissuade her from this life, has her put to death. Because of her kindness she was made into a Goddess and began her journey to heaven. However she felt such compassion for those left on earth, she chose to remain until she could ease all suffering. In another story, it was a supernatural tiger that took Kuan Yin to one of the realms of hell after her father put her to death. However, instead of being tortured, she played music and flowers bloomed all around her thereby turning hell into a paradise. It is said that one way that she eased the suffering of poverty was by giving the Oolong tea plant to a poor farmer in China. Because of this gift, his entire village was able to escape destitution.

Often in life we can feel, like Kuan Yin, as if we are caught in a type of hell. We find ourselves in hells of depression, fear, sadness, distress, or illness. Although everyone moves through these emotions during various times in our lives, our hell, our suffering, is created when we find ourselves stuck there, unable to leave. Kuan Yin teaches us compassion, not only for others but, often most importantly, compassion for ourselves. She grants us mercy and allows us to forgive. What she shows us is that who we are and who we can become can change the world around us, simply by our being. She teaches us that as opposed to practicing compassion and mercy, we need to become them. When we release our hurt and become filled with love and compassion our perspective changes and our hell changes to paradise.

She is a Goddess strongly associated with water. Water purifies us, quenches our thirst, we are born of water. We are made of water. She shows us that, like her vase that pours a never-ending flow of water, abundance is as natural and is as possible. Understand that there is a never ending supply of love, of mercy, of wealth, of all good things that are possible and of which you deserve. Trust that the Universe and Kuan Yin will provide.

There may be times when others may try to sway you, try to create you in a way that they feel is acceptable to them or to society. Living for other's expectations creates another kind of suffering. It is important to stay true to yourself. Living as you truly are and embracing life through the eyes of the Goddess, releases you. Like Kuan Yin who refused an arranged marriage to follow her spiritual calling, stay true to yourself, trust, forgive and reveal the goddess that is YOU.

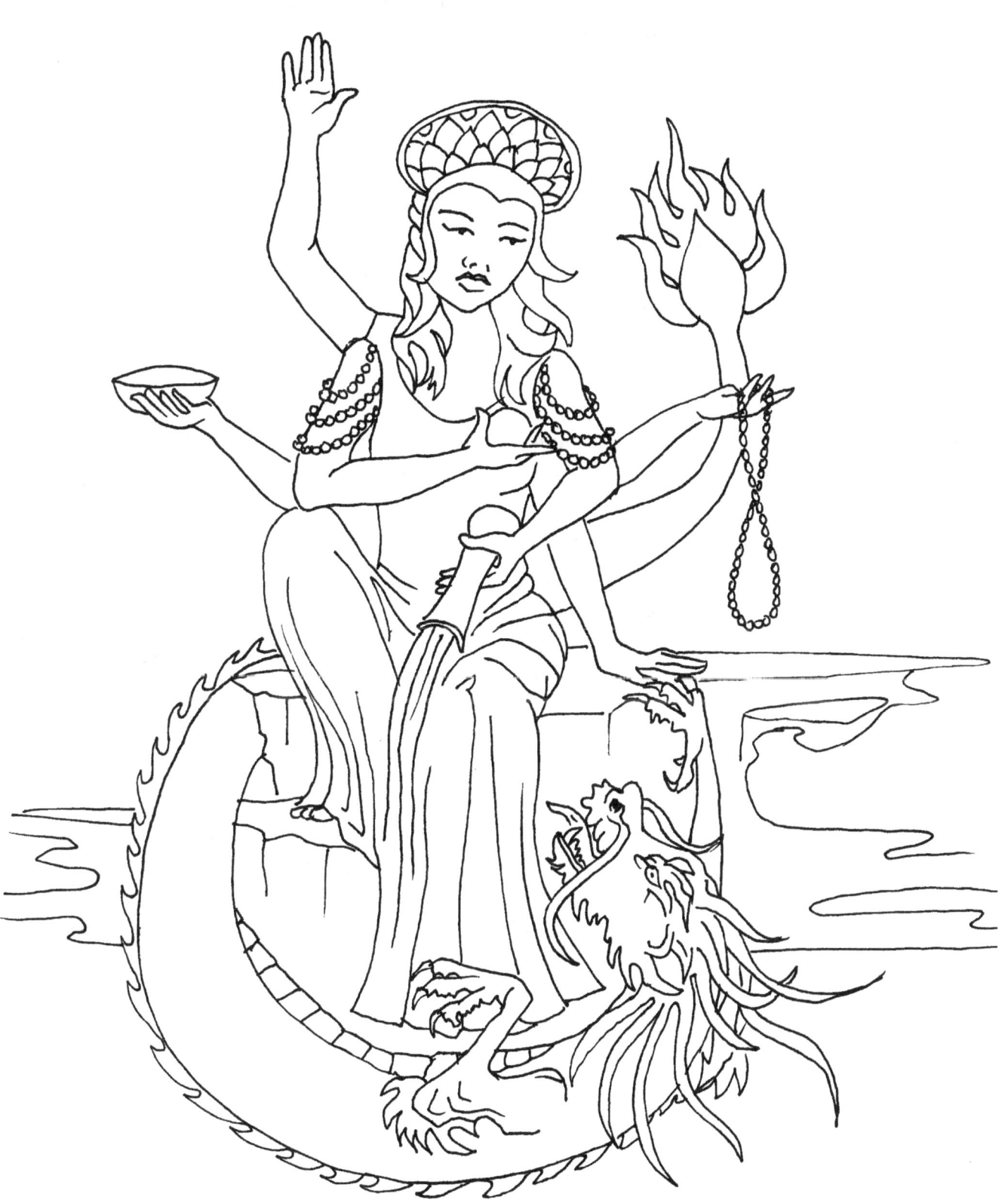

Oshun

Oshun is a Yoruba Orisha or Goddess. She is associated with love, sex, wealth, beauty and marriage. There are stories in which she is proud like the peacock. There are stories where she is selfless and sacrifices her beauty and becomes the vulture. And there is a lesser known story of Oshun as a mermaid. Fresh water is her domain, the rivers in particular. She represents our emotions and the flow of life.

In the story of Oshun as the mermaid, Oshun lives in an underground cavern where the river runs beneath the earth. She has lost her head and she has only one opportunity to find it. That time happens just once a year when the moon is full and shines through the small hole in the roof of her cave for just a few moments.

When Oshun enters your life, joy, beauty and abundance follow. She tells you to be aware of these things that already exist. She tells you to keep your heart open and do not fall prey to jealousy or envy. You may be lacking joy and sitting in fear, worried about finances or relationships. To embody Oshun you must let go of your poverty consciousness, your fears of lack and enjoy the beauty in life. It is easy to get caught up in the everyday and miss these important and beautiful moments. By becoming more aware of them and honoring them, they will increase. More and more we begin to fill our lives with love and beauty, wealth and abundance. Oshun may be smaller or seemingly less powerful than some of the others in her Orisha family, but do not let that fool you. Where she lacks in brute strength, she makes up in cunning and intelligence. She uses what she does have to her fullest advantage. And because she does not doubt or question, no one doubts or questions Her.

Do not doubt that you have what it takes to succeed. Recognize your gifts and talents, your resources and use them to their fullest. Act quickly and decisively. Sometimes we get that one shot to make something happen, to "find your head". If Oshun has stepped in, you had better step up because your time is NOW.

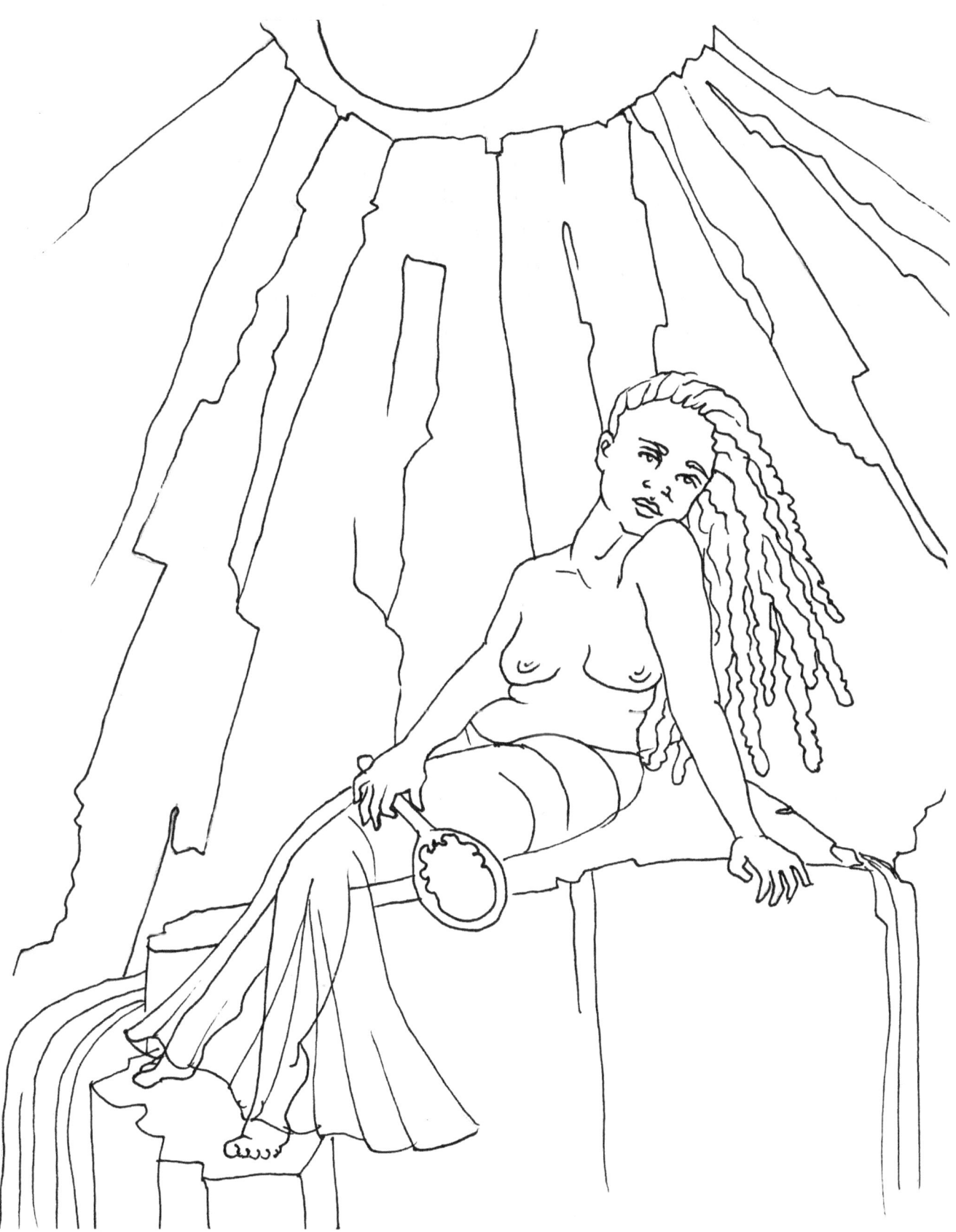

Songi

Songi is a Bantu Goddess. She is said to have come to the aid of the women in a village after a young woman named Nsomeka petitions her for help. The men of the village had been beating and mistreating the women. Songi notches Nsomeka's teeth and shares her magic with her so that from those teeth spring fruit trees, livestock and everything needed to sustain a new village. The women move into this village and take care of themselves leaving the men behind. The men, seeing their mistake and wanting to live as well as the women, apologize and promise to change their ways so that they may rejoin their wives, mothers and daughters.

Songi is about passing on our wisdom, standing up to right wrongs, and understanding the power of our words.

We often don't realize how what we say can shape our lives. Becoming aware of the words we use can be very telling. Is our language negative or fear based? Even words like "I want" and "I wish" imply that we lack. Changing it to "I have" or "I will" can change your energy and change your life.

What is your internal dialogue? Are you condemning yourself? Negating your talents and abilities? Judging yourself harshly? Whose voice are you really listening to? In Nsomeka's life the "enemy" was obvious. But sometimes the protagonist can be more subtle, sometimes our enemy can be ourselves.

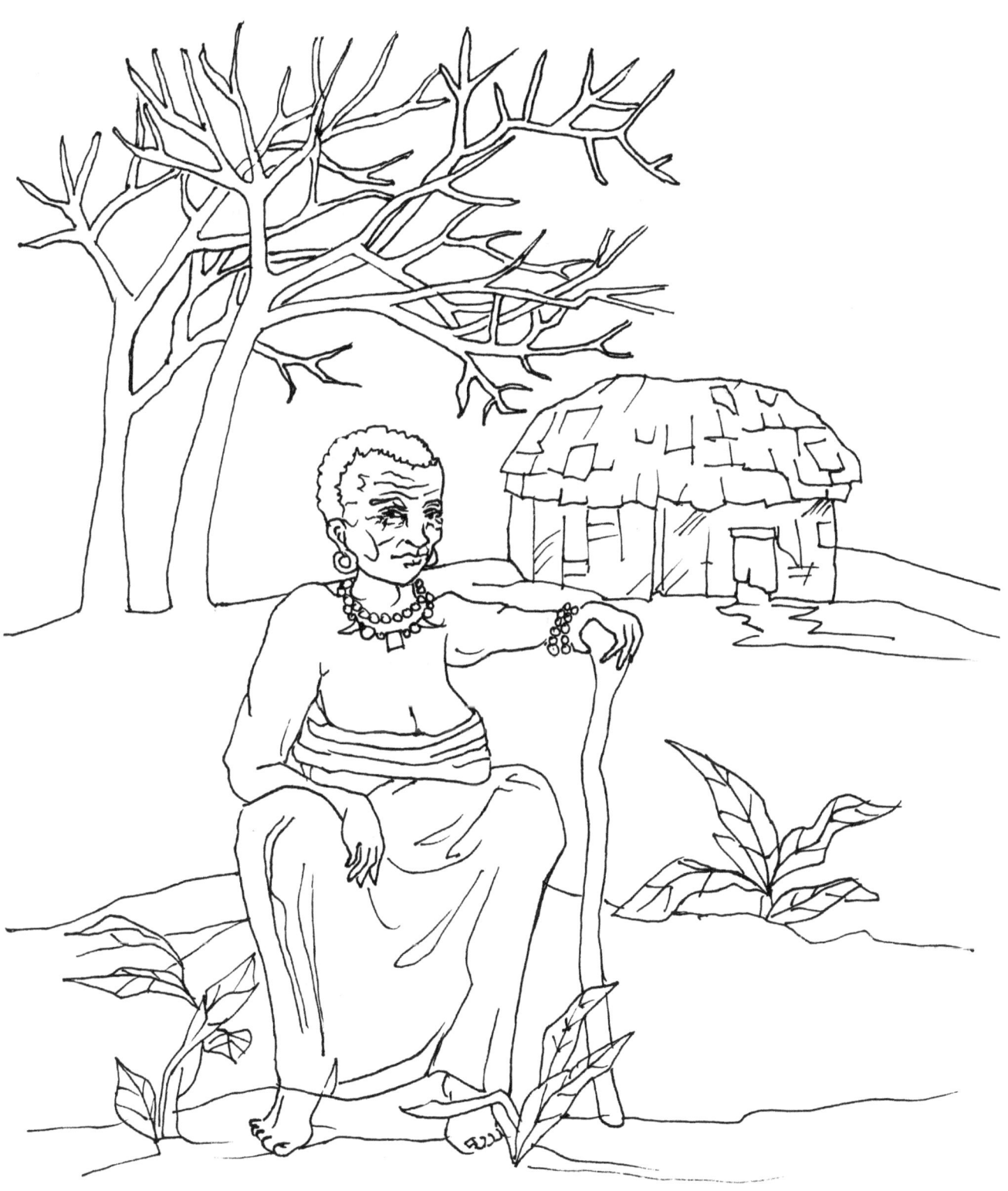

Yum Chenmo

Yum Chenmo is a Tibetan deity. She is often referred to as "The Great Mother" or "The Mother of all Buddhas" or Prajnaparamita. She is about emptiness-teaching and transcendental wisdom. In the Surcadian Oracle, Yum Chenmo sits in the Northern position of the Eastern Wheel. She combines the fire of new beginnings with wisdom and gnosis.

Recognizing that we are but thought forms, our reality is what we create, we can eliminate suffering, or the attachment to what we believe to be true. It dissipates in the knowledge that all is illusion. All is empty. All is nothing. We shape, we create, we desire, we fear, we suffer. And when we let go, we know.

Yum Chenmo is the great mother who strokes your hair and soothes your soul. She breathes into you peace that comes with wisdom. When she appears, it is time to let go. Let go of all you think you know. Let go of your attachments. With a clear head and a clear heart we learn how to practice mindfulness, to align with natural and cosmological laws, to bring joy into our lives. With the emptying comes fulfilment.

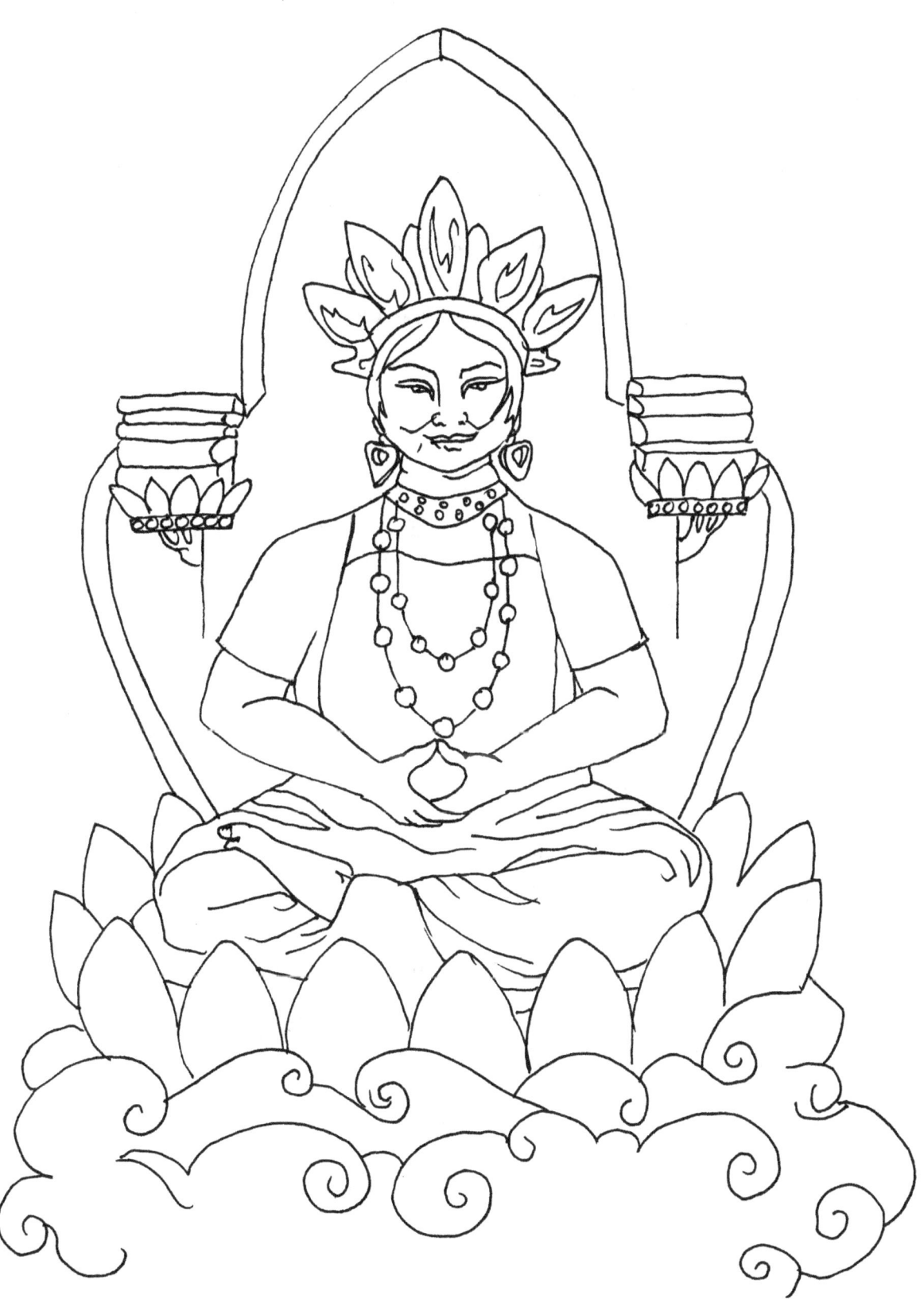

Nun Geena

NunGeena is an Australian Aboriginal Goddess of Creation. In her story, the God Baiame created a beautiful earth, resplendent and ready for man. Marmoo, in his jealousy set out to destroy it. He created a plague of insects that ravished all the living things. Leaving, seemingly nothing left. Baiame came to NunGeena. Marimoo's army wouldn't dare come too close to her. She had some flowers hidden away. From these flowers she fashioned a bird. Baiame breathed life into it and it began to eat the bugs. Nungeena gathered her maidens and they too began to create birds; birds of water and birds of heaven. They were hungry and they ate and ate until balance was restored.

Today many of us find ourselves "plagued". What we once had is being eaten away. We are losing our jobs, our homes, our cars, our health and our relationships. We are left with seemingly nothing. But we do have something. Hidden within each of us is a flower, a gift, a light, a seed. It is in a place that no one can touch. It is time for us to re-examine our resources. It is time to stop looking at what has been lost but assess and accept our situation. Look at what is left. With what we have, allow Spirit to guide us and use it to create.

From a flower, came a bird, a bird of beauty. How can beauty save the world? It was hungry. It eats and eats and eats and eats and clears away the destruction. It picks the hate, the fear the doubt and eats it. We are hungry for beauty we must fill ourselves with that. Create. Sometimes we are asked to do the spiritual thing, not the logical thing. We are asked to cast aside doubt and create even when we cannot understand how it may help or how it can cure or how it can stop the destruction and loss. Sometimes we must do the magical thing. We are never closer to god or the goddess when we create. This is the dreamtime. All things are possible. If we don't like this reality we must create a new one. Create, breathe and trust. It is the nature of the bird to eat. Don't judge your resources, use them. Use their nature. Use the nature of the beast. Work within the nature of creation and magic happens.

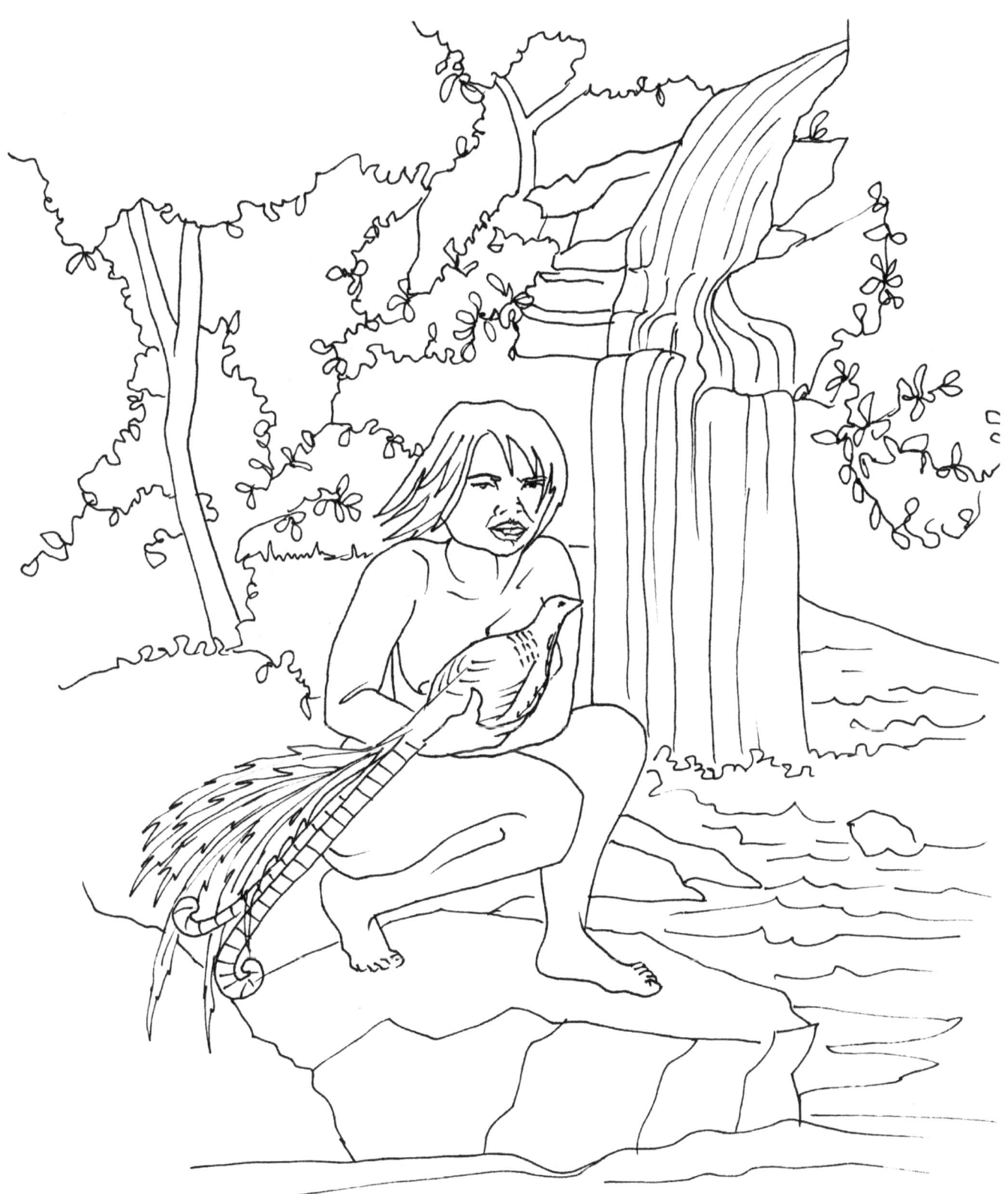

Copper Woman

Copper Woman is from the Pacific Northwest. She was the first woman on earth. The creator fashioned her from shells, minerals, seawater and covered her with copper colored skin. She survived quite well on her own finding food and shelter but she was lonely.

The Creator told her to save all her secretions in a shell. They were to be honored and were a sign that she was human. When she could accept this, she would never be alone again. From her secretions, a creature grew. Part man, part creature of the sea, he would make love to her at night and soon Copper Woman gave birth to a tiny person just like her and she was never alone again.

Copper Woman takes us back to a place of trust and surrender. She teaches us that we have what it takes to survive. We are complete and beautiful on our own. When we decide to share our lives with another, it is only through honesty with ourselves and in the acceptance of all our "human-ness" that we grow and find that we will never be lonely. Our bodies have a wisdom our minds cannot hold. To honor those parts of ourselves and experience life through our bodies allow us a greater wisdom. It is through "Rescention", the process of spiritual ascension through the reintegration of the physical self, that we can deepen ourselves and our relationships.

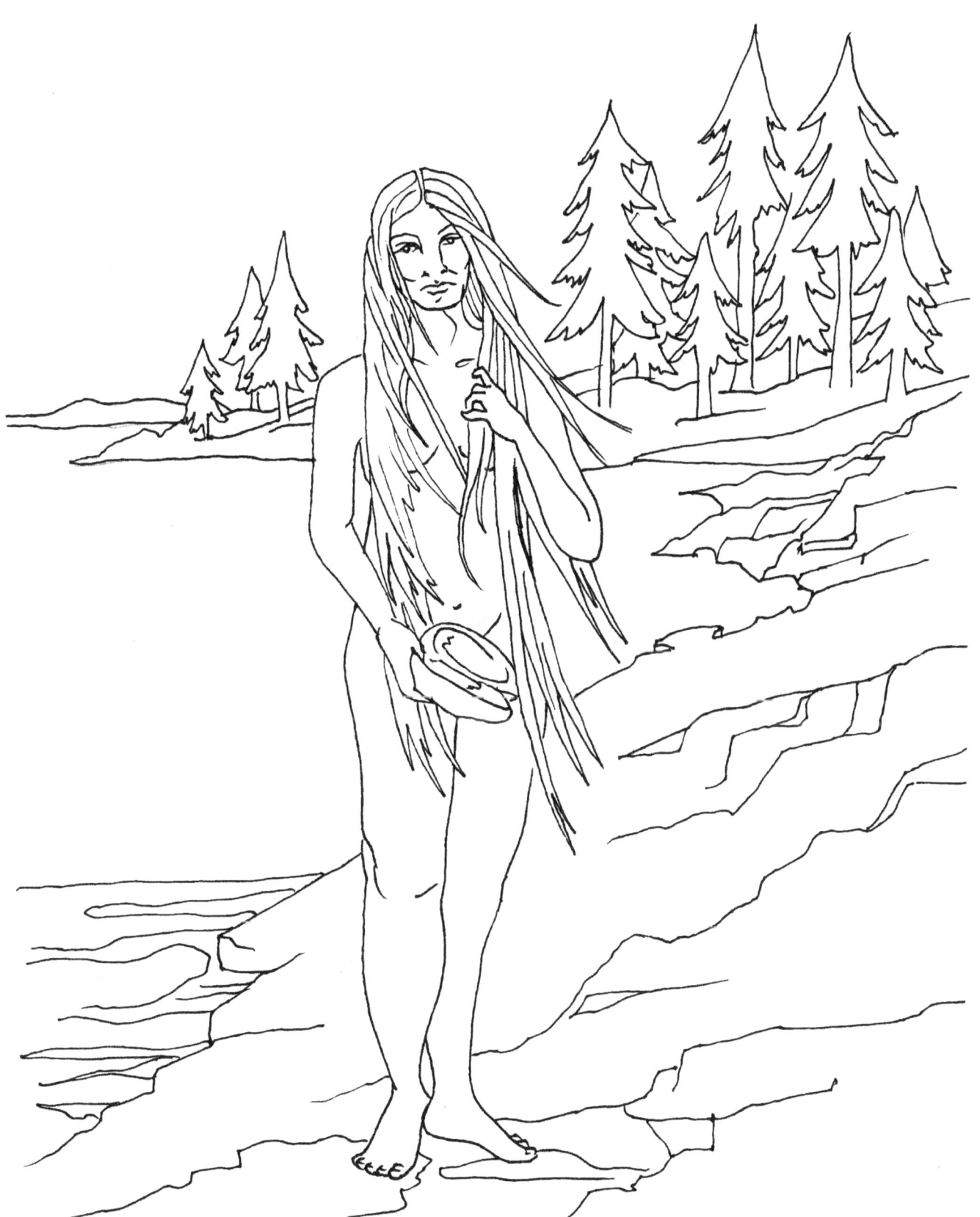

Star Maiden

It is said that the Star Maiden, along with her sisters would come to Earth once a year to bath in the waters high atop the mountain. During one of their trips, they were discovered by a bear who fell in love with the youngest and most beautiful, the Seventh Sister. The Bear hid her clothes as she was bathing and when it was time to go, she could not find her shawl. The Bear begged her to stay and only then would he return her shawl. She told him she could not, that she had to go back for she only had a limited amount of time. Her sisters, however, seeing that the two had fallen in love, gave her their combined time that they had on earth and allowed her to stay; for a while. The Star Maiden gave birth to a child but when the child was still young, her time had run out and with a terribly heavy heart, she had to leave him behind and return home to her sisters. She left with him a symbol that in time he would be able to decipher and allow him to find his way back to her.

There are times when we feel utterly alone, that we have been left behind, lost and forgotten. The Star Maiden tells us that we are not. We are of the earth and we are of the stars. We belong and we have a right and a reason for being. The map back to ourselves and to our destiny has been left for us. In order for us to decipher the symbols, we must remember. Remember our ancestors, our story, our passions and those that have helped us along the way. Remember lives already lived and the lessons learnt. These things all work together to serve as a roadmap back to our true selves and the understanding that we are part of a bigger picture, all connected and never alone.

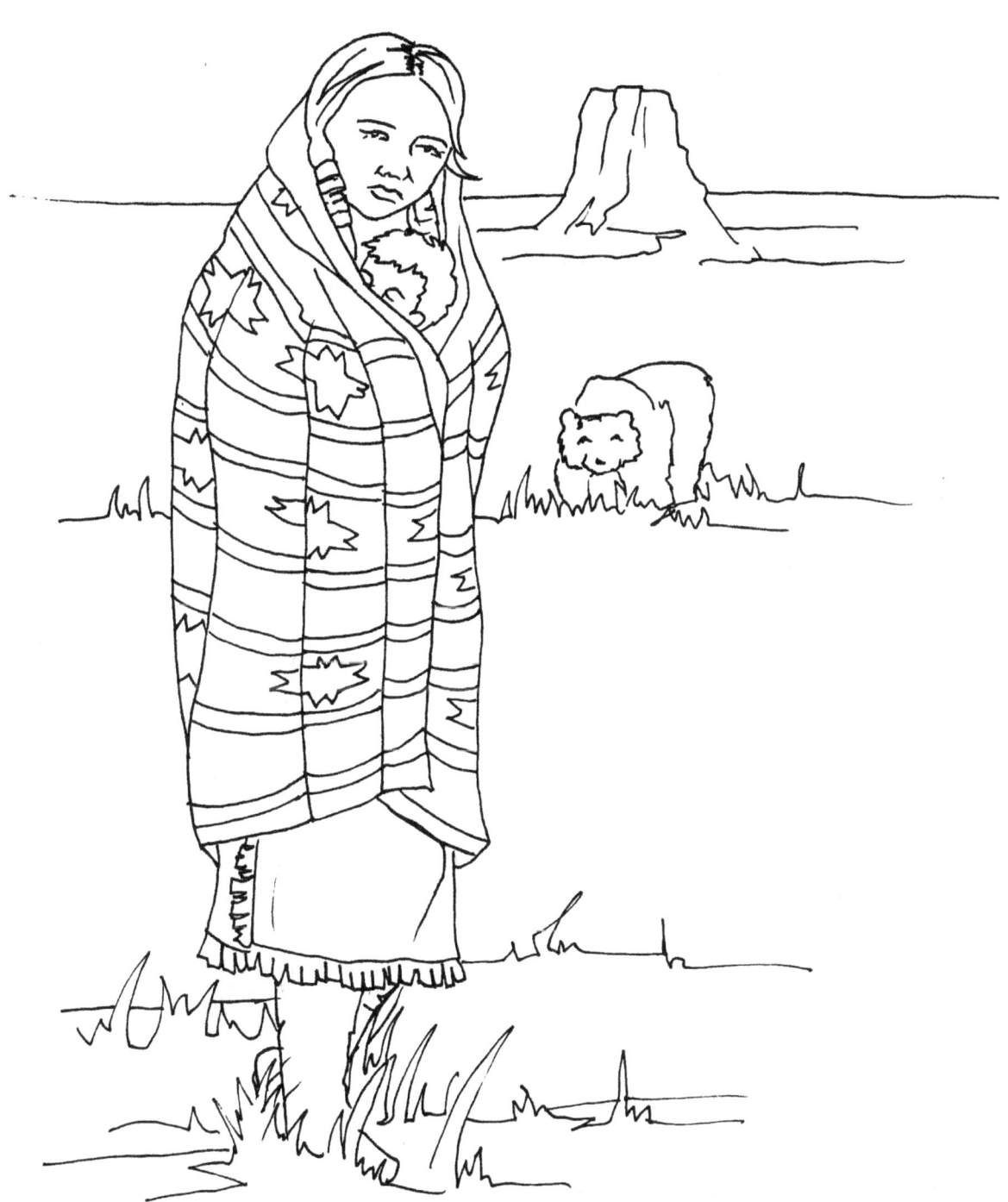

Our Lady of Fatima

Our Lady of Fatima is one of the names given to the Virgin Mary of the Catholic Church. So called because she appeared to three children in the Civil Parish of Fatima in Portugal in 1917. She, as well as the angel that preceded her arrival, gave the children messages. Some of the messages were as follows:

"Make everything you do a sacrifice, and offer it as an act of reparation for the sins by which God is offended, and as a petition for the conversion of sinners. By this you will bring peace to your country." A sacrifice means to make sacred. You are asked to make everything you do in life a sacred act. By way of your example, living life with good character, and in balance with all, you give courage to others allowing them the chance to do the same. Person by person and bit by bit, the world changes.

"Recite the rosary every day to obtain the peace for the world and the end of the war."
Meditations, mindfulness and other "M" words take practice. Awareness of yourself, your actions and your role in the bigger picture takes practice. Every day we are given an opportunity to try again. Peace begins within.

"Don't be discouraged, I will not abandon you ever. My Immaculate Heart will be your refuge and through it will conduct you to God."

Mary's Immaculate Heart refers to her life, her joys, her pain, her actions, her character and her virtue. We can relate to her because she experienced real life like we do. She has compassion for us because she was once there too. The image of the Immaculate Heart is traditionally pierced by seven swords. These represent the Seven Dolors of Mary or the seven life events that affected her and consequently all of us, in a very large way. By embracing her immaculate heart, we embrace all of the pain as well as the joys that constitute life. We understand that although we can be hurt, we cannot be harmed. Moving into that place of love that is bigger than any of the stresses we incur in life is a place of salvation. Here we can breathe and put things into perspective. Here we can rest a moment, recollect our thoughts and our courage allowing us to step out into life once more and try again to make a difference.

When Our Lady of Fatima shows Herself, it's time to pray, to breath, to go to that place of love and compassion. It's time to walk your talk and by your example, give others the strength to do the same.

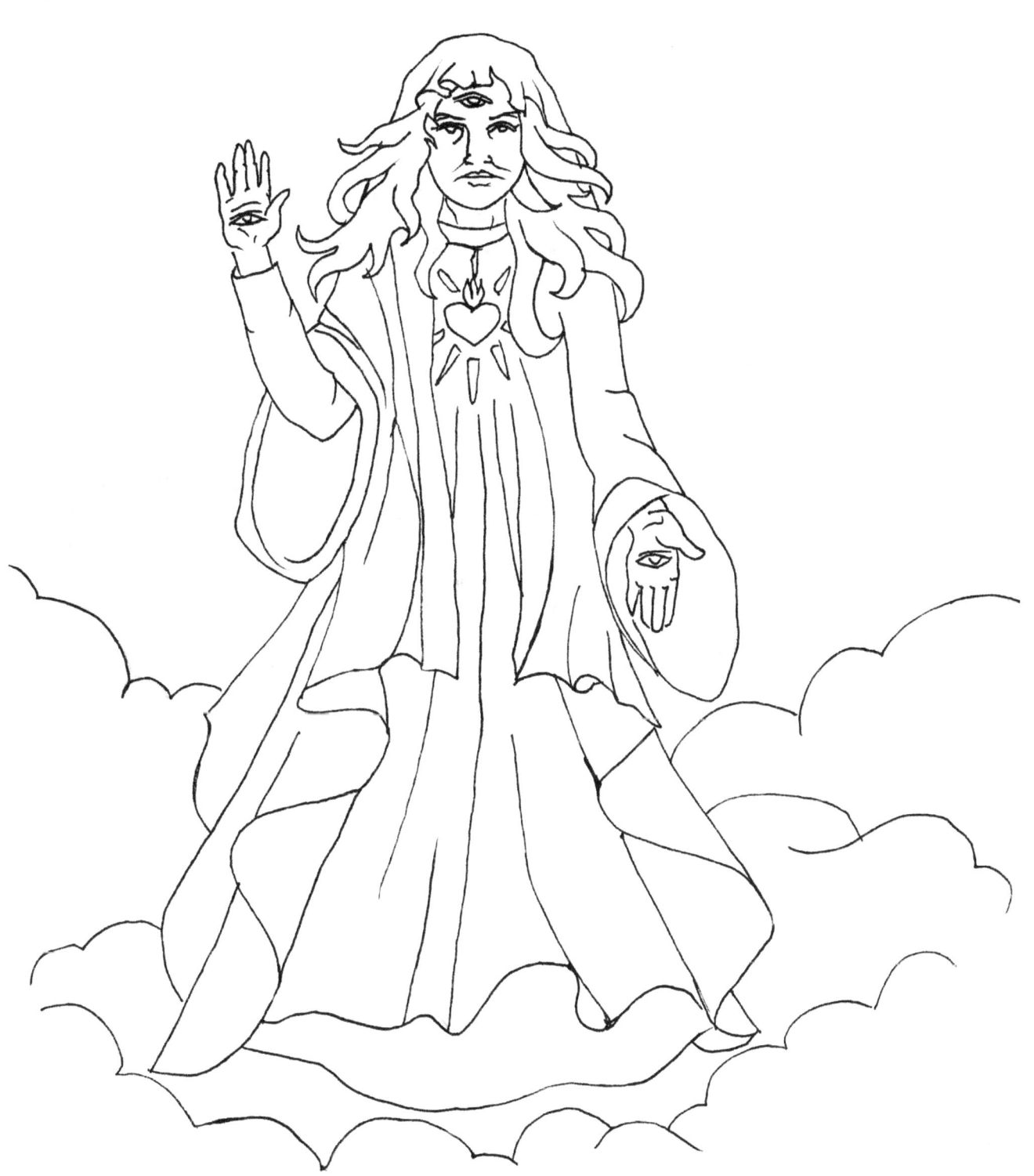

Sophia

Sophia is considered to be a goddess of wisdom in Hellenistic traditions. The name Sophia in Greek translates as wisdom. The wisdom Sophia gifts us takes place inside of ourselves. To work with Sophia means it is time to break through your illusions, your delusions and the lies you tell yourself.

This commitment is one that can result in pain as your ego falls away and your true self is revealed. The results are always worth it. The process is difficult.

Wisdom comes through experience. Don't hold back. Do not choose to remain quiet because you fear humiliation if you speak. Do not choose to hide because you fear what people will think if you are seen. Things perceived as "bad" are lessons to be learned. They are opportunities for growth and change. Humiliation brings humility. Humility is the understanding that not everything is about us. Wisdom comes with the realization that there is something more, something bigger than what it is we see and the understanding of our role within that.

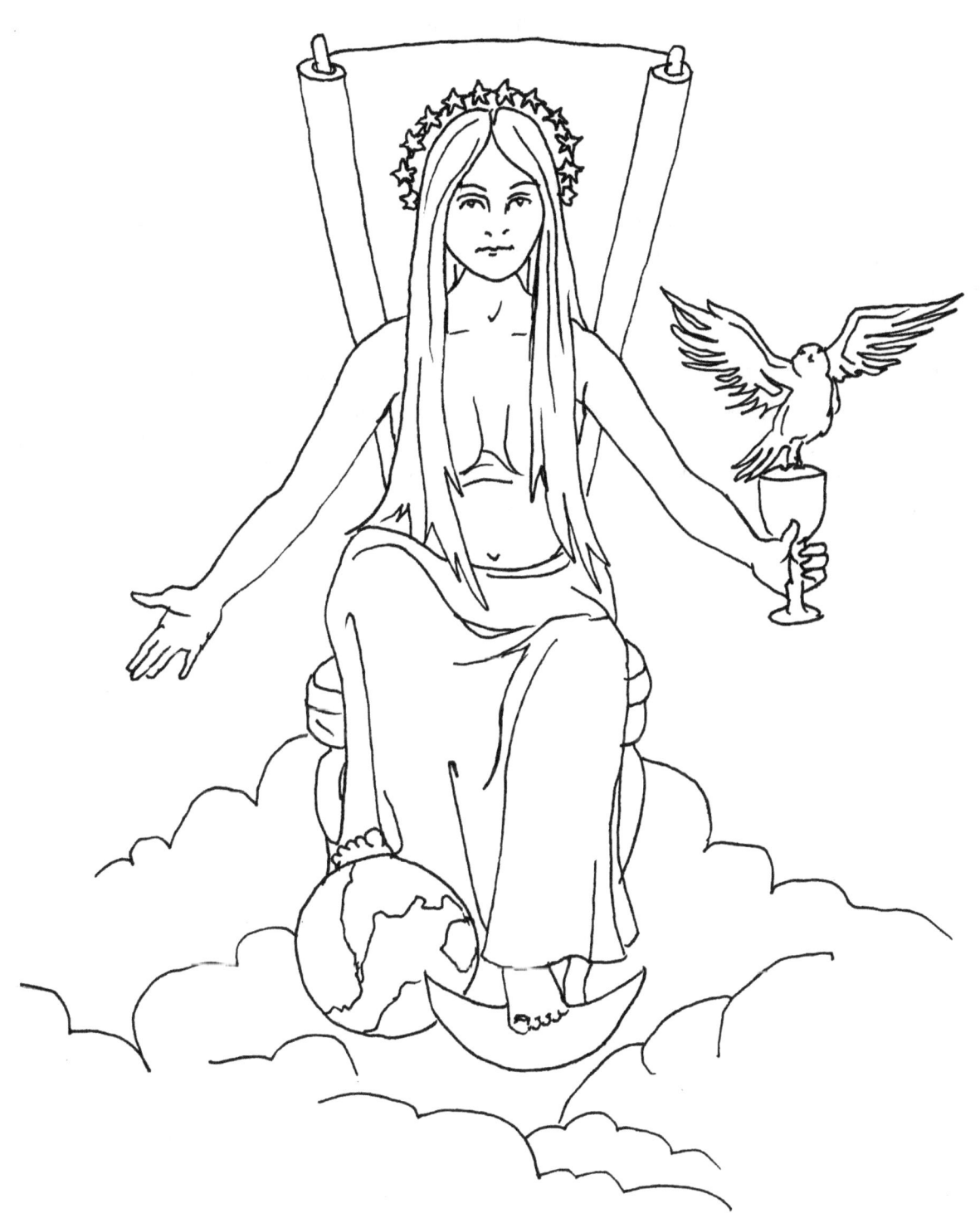

Mother Night

Mother Night is known by several names, she is the central deity in the Feri Tradition of American Witchcraft. She is the point of all creation, She is primal, She is chaos. She is deep space with no beginning and no end. She is where everything and nothing is possible. She is ancient and has always been while at the same time, she is yet to be.

In the dark womb of the Mother you wait to be born. In the dark womb of the Mother you will return after death. The chaos you experience now will give birth to an amazing creation. You are becoming the Mother and there is a new life growing within. Your world, your life, your experience, your choices, your story is yours alone. Take the pieces that are all around you, the stars floating in the darkness and fashion them into a galaxy. You have it within you to create your reality. The time is now.

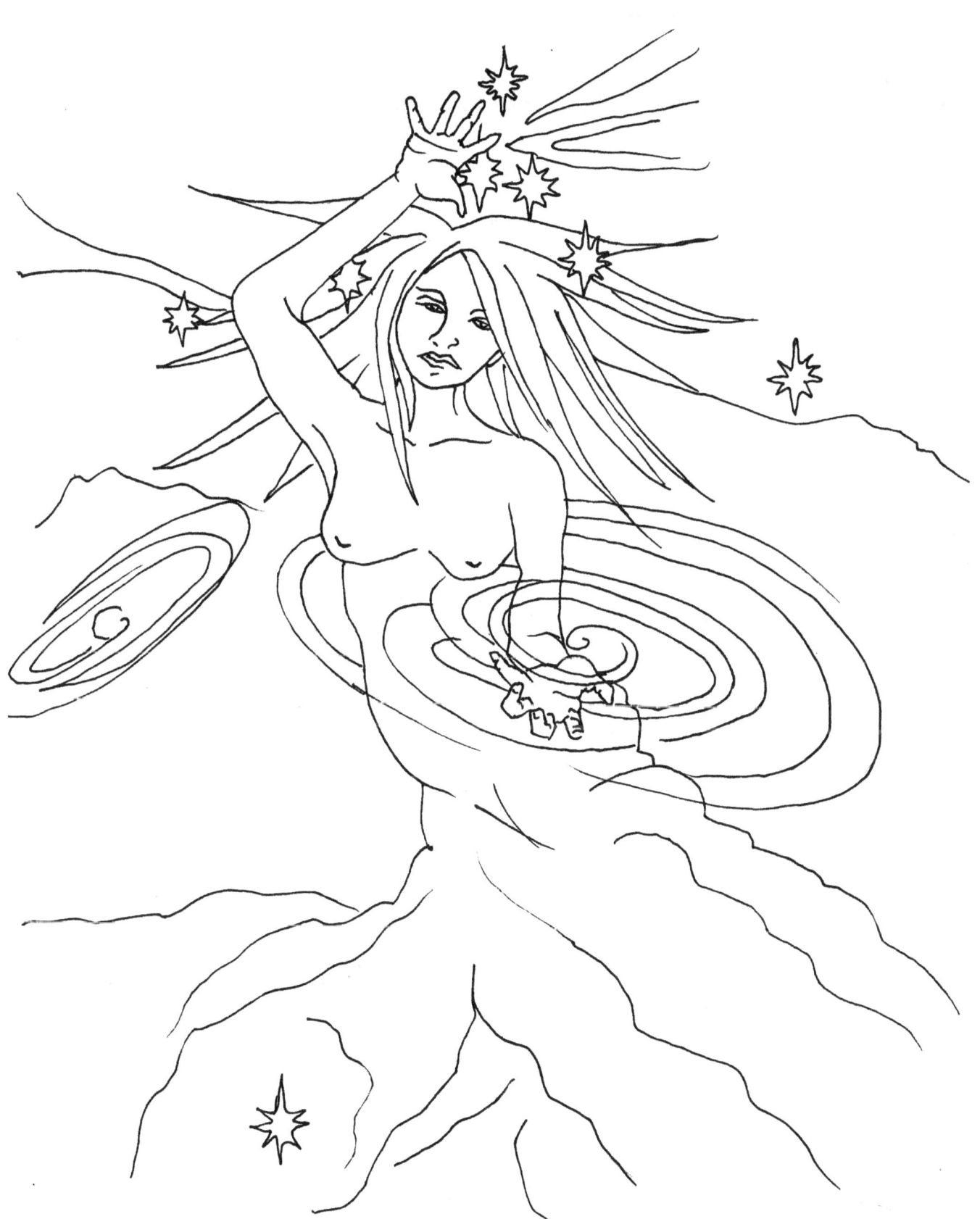

About the Creator of The Goddess Coloring Book

Kate Henriott-Jauw has been awakening and activating the goddess within herself and others ever since her now grown daughter asked her about witches and wizards many years ago. It was then that she decided to shed the costume, drop the props and walk off the stage of suburbia to reclaim herself and has never looked back. Through her journey of awakenings she has discovered that the Goddess is very real and lives within each one of us.

She along with her husband; author, speaker, Ted Jauw have been bringing to life the world of Surcadia. Of which these Goddesses are a part. Surcadia is Place and Time and it is here that the principles, perceptions and people of a new era will live in a world that is at once familiar and faraway. It is both and neither

Other Books in the World of Surcadia

The Surcadian Chronicles Book 1: The Fourth Choice by Ted Jauw
The Surcadian Chronicles Book 2: The Fifth World by Ted Jauw
The Surcadian Chronicles Book 3: The Sixth Chakra by Ted Jauw
Remergence by K. Henriott-Jauw & Ted Jauw
Rescention by K. Henriott-Jauw & Ted Jauw

Surcadia is Copyright © 2013-2015